# CIMABUE
## A CRITICAL STUDY

# CIMABUE

## A CRITICAL STUDY

BY

ALFRED NICHOLSON

KENNIKAT PRESS
Port Washington, N. Y./London

CIMABUE

Copyright, 1932, Princeton University Press
Reissued in 1972 by Kennikat Press by arrangement
Library of Congress Catalog Card No: 71-159097
ISBN 0-8046-1640-X

Manufactured by Taylor Publishing Company      Dallas, Texas

BK
5-17-80

# PREFACE

T HE main objective of the following pages is a readable defini-
tion of Cimabue's art, with adequate reproductions of his ex-
tant work. Towards this end all bibliographical and all but the
more significant archaeological matter has been relegated to the
notes and appendices. Yet my indebtedness to the work of predecessors
is obvious, and, I hope, acknowledged. Otherwise I am grateful chiefly to
the Berensons, to Professor Mather, and to my wife, for their assistance in
various indispensable ways. The heretofore unpublished details from the
upper church in Assisi were taken by Brogi of Florence, as indicated.

Settignano and Princeton
    1928–1930

# ILLUSTRATIONS

# CIMABUE

## I

AMONG great Italian painters Cimabue has been the most elusive to archaeological and aesthetic reconstruction. In the first years of this century both the conscientious critic and he who wished to evade the difficult issue rejected the faith, finding the Cimabue legend an inexplicable tangle of possible fact and certain fancy, which the meager documentary evidence did nothing to control.[1] And even when the clue was discovered, little more than the ruins of his not readily understandable art remained.

Since then *dugento* painting has become the object of some scholarship and of much indiscriminate enthusiasm. But though every fifth-rate icon artificer bids fair to become a Master in his own right, the name of Cimabue is still spoken with awed misconception, and the peculiarities of his style and aesthetic construction, as distinct from those of his contemporaries and immediate predecessors, are not well defined. At best he is mentioned as a tragic artist, an architectonic and monumental decorator, a *dugento* Michelangelo who poured the ferment of a virile intelligence into the ancient bottles of Byzance. He is the unexpected fulfilment of an old tradition and a liberating force for a new. Some demonstration of these and of other vague hypotheses is undoubtedly latent in the minds of many scholars; but no one, to my knowledge, has propounded them. The abundant bibliography, when not archaeological, has wavered between appreciative and sceptical polemic, and except for a more adequate proof of the existence of work attributable to our painter, the criticism of Cimabue has altered and developed only in detail from what it was with Thode and Strzygowski over forty years ago.[2] Now that polemic is no longer required, an attempt to comprehend this work should be worth while.

Since by far the greatest body of his extant or partially extant work is in the choir and transepts of the upper church of San Francesco at Assisi, and since many of these frescoes are not commonly known, an iconographical and descriptive account of them may be excusable. Their iconography is one determinant of his art; but to stop with it would be to treat the subject with complete inadequacy. For the author of the works here attributed to Cimabue was no conventional church painter, but a great aesthetic constructor who, no matter how unconsciously, used tradition and the requirements imposed upon him for his own ends. Therefore an analytical and comparative account of the aesthetic experience induced by his work is also necessary; and this, combined with the scrupulous use of archaeological matter of every sort, is the only approach towards that comprehension which is the normal if unattainable end of the study of any real artist or of art itself.[3] Such a statement is obvious, but its full truth is often evaded both by the enthusiasts of art criticism and by those scholars who rightly think that a bad aesthetic analysis is worse than none at all.

## II

To acquire any adequate knowledge of these ruins in the choir and transepts of the upper church, and a discriminating sense for the spirit and style of their chief executant, requires an application to reproductions and written suggestions which involves some preliminary tedium. Whether or not these frescoes were mostly the work of the Cimabue from whom the legend evolved, and of the Cenni de Pepi of the documents, who received the apparently opprobrious nickname of Cimabue or Oxhead, is a matter of secondary importance. Yet the reasons for this attribution will be incidentally confirmed and developed in the course of this study. The change that has reduced most of these frescoes to their present state has never been adequately explained. But it is almost certain that the colors of much of the surface painting had a white lead base which soon oxidized to black.[4] Their likeness to photographic negatives, which has often been noted, is more evident in the photo-

graphs than in the originals, which present a contrast between black and ochre with the lights generally reversed, and with much of the original blue remaining in the backgrounds.

Since the four Evangelists in the central vault are the most notable exceptions to this change, retaining much of their original appearance, and since the style of their execution is in every way similar to that of the finest work to be found here, an account of the decoration may begin with them. Moreover the normal procedure of decoration was from the vaults down; so that these were probably among the master's first works in the church.

In each section of this quadripartite choir-vault an Evangelist is seated with his gospel at a desk below which is his proper beast. (Figs. 1–4.) An inspirational angel appears from above and in the angle opposite is a portion of the world allotted to each and represented by architecture. Close iconographical derivations, without symbolic cities or geographical inscriptions, may be found in the frontispieces of many Greek Gospels,[5] and on the pendentives below the central domes of certain Byzantine churches—a fact which may help to explain their position in the upper church. But here the figures, especially those of Matthew and Luke, assume an astonishing power. The patterns of the figures are broad, yet firmly knit, and the heads and features are severely plastic. There will be noted a repetition of the *curved angle* which seems to be the basic constructive and unifying motif of these figures. It is insistently used with infinite variations in their attitudes, in the lines of the drapery, and in the facial structure. Their angular gestures are emphasized by the enormous hands that protrude and curve from the wrist. These angles seem to ramify in three dimensions, and with the shading of their sub-tended surfaces suggest form. The shading of the draperies is indeed not always understood for a realization of bulk; but what the torsoes may lose in weight is amply atoned for by the suggestion of great limbs beneath the draperies, by the powerful hands and feet, the sculptural heads, and the insistence upon the geometrical scheme. Something of this will of course be found in the best Byzantine work, but in most of

it there are superfluities which may have had their hieratic value, but
serve neither to unify the pattern nor to create form; and in certain
ways the best aesthetic analogies to these Evangelists and to most of
the works to be considered in this chapter will be found in the paintings
of the most vigorous Chinese artists. Their figure art, however, is usually
more fluid and does not attempt sculptural or structural effect. One
should also note how the figures fit into the spaces framed by the broad
decorative strips of stereotyped foliation and heads of *putti* which follow
the ribs of the vaulting. For, either by chance or unconscious design,
they not only give back the lines of their frames, but repeat something
of the very structure and rhythm of the vaulting itself. An attempt to
develop these suggestions will be made later, but they may be kept in
mind during the consideration of the rest of the paintings.

The dating of these works cannot be assigned on architectural evi-
dence with the least exactness, since the walls probably stood for decades
before the decoration began.[6] But on one of the painted structures in
the architectural group opposite St. Mark (Fig. 2), which is supposed
to represent Rome, the Orsini arms, consisting of three bends on the
lower field and a single rose above, appear three times.[7] Nicholas III,
who became pope in 1277 and died in 1280, was of the Orsini family, and
is known to have held the Franciscans in high esteem. It has therefore
been supposed that this part of the decoration of the upper church may
be dated from the years of his papacy. How tenuous is the thread from
which such a supposition hangs is obvious when one realizes that the
Orsini family was a large one, and that even if these arms are to be
associated with that member of the family who became Nicholas III,
their painting need not necessarily concur with the exact period of his
pontificate. They may very well have been set there as a memorial after
his death, or even as a mere representation of the arms then actually
on St. John Lateran. But taking all things into consideration, one may
think about 1280 the earliest possible date for these frescoes of the
Evangelists, in which such a maturity of style and technique is evident.
And whether this is the approximate date of Cimabue's arrival at Assisi,

or whether it occurred almost ten years later, following the impetus
given by the first Franciscan pope, Nicholas IV (1288–1292), it is im-
possible to say.[8] Yet judging from what is known of contemporary Roman
and Tuscan work, and not wishing to consider our artist more of an
innovator in the mastery of fresco than may reasonably be supposed,
the writer favors this slightly later dating. Moreover the ornamental
strips surrounding Cimabue's work are not dissimilar in general style
from those of the nave, and suggest a continuity of labor.[9] But since
some of even the earliest painting in the nave betrays the influence of
Cimabue, one may consider most of the work in the choir and transepts
at least slightly anterior to it.

Bare suggestions for the subjects to be presented in much of the
remaining decoration of the choir and transepts seem to have been
derived from the *Legendae Duae* of Bonaventura. In 1266 the Seraphic
Doctor, with the ostensible desire of unifying the factions in the Order,
passed a decree that only his account of its sainted founder should be
orthodox, and thus helped to define Franciscan iconography. This in-
fluence upon the St. Francis series in the nave is well known; but Bona-
ventura insisted upon the saint's devotion to the Virgin, to the Angels,
especially Michael, to the Apostles, especially Peter and Paul, and of
course to Christ Crucified. These are the only members of the conven-
tional hierarchy which he mentions as being the objects of St. Francis's
especial devotion; and it is these passionate predilections of the saint,
combined with a Franciscan interpretation of the Apocalypse, that were
considered in the decoration of the apse and transepts. To effect a pic-
torial translation of this matter both the orthodox and apocryphal
accounts of these hieratic figures and the text of *Revelation* were put
to use. And while a few of the scenes and many of the iconographical
and even aesthetic details may be traced to other pictorial sources, it
seems almost certain that we are here confronted by what is virtually
a new iconography which gave more tractable material for aesthetic
construction than was usual at the time.[10] This emphatically does not

mean that the complete decorative effect is one of mere personal whim; and the manner in which the painter subjected his material to its architectural setting, and made it as it were an organic part of the architecture, will be an important consideration in this study.

The upper part of the left transept is devoted to Saint Michael and the angels.[11] In the arched recess above the west gallery are the remnants of a scene presenting the chivalric archangel with two aides quelling the Serpent and divers demons (detail, Fig. 6). Analogies to this theme may be found in earlier Italian church decoration, as at S. Pietro al Monte in Civate; but the significance was undoubtedly new and was repeated in other Franciscan churches, such as Santa Croce in Florence, and San Francesco in Arezzo. Bonaventura's eloquent, if overloaded Latin may be freely translated as follows:

> To the angels who burn with wondrous fire to excel in God and in the kindled souls of the elect, was he [St. Francis] bound with inseparable love; and because of his devotion towards them he fasted forty days after the Assumption of the glorious Virgin, calling upon them with insistent prayer. And even greater was his love for the blessed archangel Michael, who presents souls [to judgment] and who is zealous that all should be saved.[12]

But the scene of Michael and the Dragon is of course also related with the apocalyptic cycle beneath. This series begins below the gallery to the left of the apse.[13] In the first section (Fig. 7) are two haloed figures seated upon a great rock amid swirling waters in which leap many speckled fish drawn with lively precision. Closer observation will reveal that the figure to the left is winged, and that in the hand of its outstretched right arm is a slender straight object—probably a stylus. This angel turns toward the other figure—a most Cimabuean old man with a look on his face as of one who sees strange portents. No inscription is necessary to identify this as John on Patmos with the angel.[14]

> The Revelation of Jesus Christ, which God gave unto him, to shew unto his servants things that must shortly come to pass; and he sent and signified it by his angel unto his servant John.—*Revelation* i. 1.

The first vision is the Fall of Babylon (detail, Fig. 8). From the

upper left an angel appears out of a heaven symbolized by seven concentric arcs. Judgment has fallen upon that mighty city, that mother of harlots and abominations. Her houses are tumbled about in cubistic confusion, and her gates are thrown open. Little in the immediate foreground but a stalking ostrich—an ancient symbol of heresy,[15] and a group of demons is plainly discernible; but the closest inspection will unmistakably reveal two women issuing from the left gate, and three more on the left edge turning about in horror of the shapes in the center with their shaggy outstretched arms; while far to the right (now hidden by choir stalls) are other demons with bat-like wings.

> And after these things I saw another angel come down from heaven, having great power; and the earth was lightened with his glory. And he cried mightily with a strong voice, saying, Babylon the great is fallen, is fallen, and is become the habitation of devils, and the hold of every foul spirit, and a cage of every unclean and hateful bird. . . . And I heard another voice from heaven saying, Come out of her, my people, that ye be not partakers of her sins, and that ye receive not of her plagues.—*Revelation* xviii. 1, 2, and 4.

Thus the angel, the women, the devils, and the detestable bird are easily accounted for, and the remarkable effect of architectural overthrow is perhaps heightened by the ruin of the fresco.[16]

In the first scene on the end wall (Fig. 9) Christ appears within the mystical ellipse, with the book of the seven seals in his hand, and surrounded by seven trumpeting angels. In the center is an altar, with a censer-bearing angel to the right of it, and a host of suppliants beneath.

> And I saw the seven angels which stood before God, and to them were given seven trumpets. And another angel came and stood at the altar, having a golden censer; and there was given unto him much incense that he should offer it with the prayers of all saints upon the golden altar which was before the throne. . . . And the angel took the censer, and filled it with fire of the altar, and cast it into the earth; and there were voices and thunderings and lightnings and an earthquake. And the seven angels which had the seven trumpets prepared themselves to sound.—*Revelation* viii. 2, 3, 5, and 6.

The crowd below is divided into two groups; the foremost figure in the left group, being a tonsured monk, has usually been taken for St. Francis.

But since neither nimbus nor *stigmata* are visible, this identification is doubtful. These suppliants probably represent a part of the one hundred and forty-four thousand who were to be "sealed" (*Revelation* vii. 4); and the two heads that retain much of their original quality (Fig. 9a) suggest the vehemence and structural impetus applied to the brush that painted them.

In the next section (Fig. 10) is an almost obliterated angel flying out of another concentric heaven in which the face of a sun is fixed. Before a high walled city below are four angels bearing horns of plenty which held the four winds.

> And after these things I saw four angels standing on the four corners of the earth, holding the four winds of the earth, that the wind should not blow on the earth, nor on the sea, nor on any tree. And I saw another angel ascending from the east, having the seal of the living God: and he cried with a loud voice to the four angels to whom it was given to hurt the earth and the sea, Saying, Hurt not the earth, neither the sea, nor the trees, till we have sealed the servants of our God in their foreheads.—*Revelation* vii. 1–3.

Though attempts to solve frequently non-existent allegories are as dull as they are fruitless, we have Bonaventura's word to prove that this angel who bore the seal of the living God was interpreted as being St. Francis himself.[17] The seal in this case was the *stigmata* or *l'ultimo sigillo* as Dante called it (*Par.* xi. 107).

The last apocalyptic scene is a revision of the "Preparation of the Throne" or *Hetimasia* (Fig. 11). Encircling the throne are the four evangelical beasts, the twenty-four elders, and many angels. Against the back of the throne to the upper left, and so holy that it needs no support, is the book with its seven seals; and on the throne, swaddled and haloed with a cruciferous nimbus, is the divine Child, his two hands just discernible. There is frequent mention in the Apocalypse of the throne, of the book, the beasts, and the elders with their crowns, musical instruments, and "vials full of odours"; and conventionalized representations of them were common in Italo-Byzantine church decoration, as in S. Giovanni Porta Latina, S. Elia near Nepi and the crypt of the Anagni

*duomo.* But the usual *Hetimasia* was a more or less misunderstood survival of Byzantine despotism, the throne being the awful symbol of a combined temporal and spiritual power, and the book revealing at once the Word of God and the Code of Justinian. A similar arrangement of the heavenly host with its appurtenances will be found in such a miniature as that in the Apocalypse of St. Sever [18] and, with greater variations, on the tympana of certain Romanesque churches. But here of course the central figure is the man Christ, not the swaddled Child on the throne. A tradition of apocalyptic illustration in miniatures existed at this time, especially in the North, and it is evident that superficial iconographical suggestions were taken from such illustrated manuscripts,[19] but in the upper church, so far as we can now tell, even the compositions of these sections, to say nothing of their style and import, underwent significant changes.

Any exact reconstruction of the symbolism of this apocalyptic cycle is of course impossible. Perhaps it was always intended to be something of a mystery except to the initiated. But we know that throughout most of the *dugento* the long war between Papacy and Empire and the battles of the rising Communes had helped to revive a general dread of final Judgment and a hope that the Millennium for the elect was at hand. Frederic II and his successors were sufficient Anti-Christs for the Guelphs; each pestilence, earthquake and eclipse was more than ever ominous; and a climax of fanatic confusion was attained in 1260, when, according to the probably exaggerated accounts of the chroniclers, populations of whole cities turned into routs of flagellants seeking to avert imminent doom. Among the Franciscans Millennial heresies were rife— especially that of Joachim, for the acceptance of which one of the greatest generals of the Order, John of Parma, was deposed.[20] Though repudiated by the Church, these heresies did not easily die. Even Bonaventura, in his official life of the Saint, not only saw in him an Angel of the Apocalypse, but dangerously emphasized an analogy between him and Christ. Thus to many Franciscans St. Francis seemed all but the Son of Man in his second coming, and a portentous angel of the Word.

The vague and terrific poetry of *Revelation* has always offered excellent material for any interpretation whatsoever. But some outline of the symbolic construction to be found in these scenes in the upper church seems comparatively obvious. Thus the Quelling of the Dragon and the Fall of Babylon mean of course the overthrow of the world, the flesh and the devil. Perhaps church corruption and almost everything that was not Franciscan were involved.[21] In the next scene the destruction administered by the censer-bearing angel continues; but the elect have begun to take refuge below the mystical altar. The next scene presents St. Francis as an angel of mercy warning the Winds not to complete the destruction till all the elect should be gathered; and finally appears the vision of the throne with the Child upon it, the heavenly *Praesepium* and rebirth of Christ.

It is needless to say that this symbolic construction must have been given to the painter by Franciscan authority; and though one cannot tell to what extent he depended upon existing miniatures for the presentation of it, this series has a stylistic and emotional unity and a dramatic sequence of its own, which no hackneyed revamping of prototypes could give. But though the painter's strongly personal stylization and his sense for imaginative drama have saved these scenes from the limbo of mere symbolism, he, like most of the great Florentines, was not at his best until he was coping with physical actuality. The theme of the Crucifixion lent itself more readily to this treatment, and his well known presentation of this subject on the east wall of the left transept is, among extant works, his accepted masterpiece.

Iconographically considered, this Crucifixion (Fig. 12) seems to have had as one of its most direct prototypes that of the so-called Master of St. Francis, which Cimabue would have had before his eyes whenever he entered the lower church.[22] Unfortunately only the group to the left of the cross—the dolorous women and St. John—is now extant, but a comparison of the two groups (Figs. 12b and 13) will show their affinities. Moreover, in the section preceding this in the lower church there

is a compact group of old men who composed the right half of a Prepara-
tion of the Cross, and who were undoubtedly repeated with appropriate
gestures in the Crucifixion itself. But though one may still trace the bare
arrangement of the theme and nearly all of its iconographical details to
earlier presentations, one finds in this Crucifixion of the upper church a
tragic clash of unprecedented significance.

The colossal body of the dead Christ is the center of an elemental
conflict, evident in the storm of angels and in the loin cloth lacerated by
a great wind. On the faces of the compact and violently drawn group
to the right is a mixture of imbecile savagery and fearful comprehension,
and the sainted centurion and an ancient Hebrew behind him indicate
with their right arms the Messiah, "Truly this was the Son of God."
In the group to the left, John clasps the hand of his newly adopted
mother; and in the quietly rhythmic gestures of these sorrowful women
and of the Evangelist there is something of a low musical complaint
which becomes suddenly strident in the upthrust arms of the Magdalen.
Behind this group are the many women who followed Jesus from Galilee;
and huddled on the rock at the cross's base above the skull of Adam is
St. Francis, seeking obliteration in Christ Crucified.

No really comparable presentation of the theme is to be found else-
where. For this Crucifixion is not an exquisitely felt narrative, a display
of naturalistic or technical dexterity, or primarily even a mystical experi-
ence. It is the climactic moment of an objective universal drama. This
Christ, like a new Prometheus, is the grand protagonist of humanity;
and without stressing the simile, one may conclude that the painter,
though perhaps no very ardent Franciscan himself, bodied forth ade-
quately for the first and last time their early passion universalized by
mediaeval thought.[23]

The chemical change that has blackened this fresco seems to have
exaggerated its linear quality, and something of the original plasticity
will probably be seen to better advantage when the lights are reversed
as in Fig. 12. Though it would be dangerous to judge the original effect
of the work from this reproduction, relief is here effected by abrupt

transitions from light to dark, by broad sculptural gashes in the draper-
ies and by schematic incisions in the heads suggesting structure. It is
scarcely necessary to point out how the composition is centralized upon
the Crucified, or to note how the sense of dynamic force produced by
the compact group of savage figures contrasts with the high sorrow of
the figures to the left, which are like so many human columns combined
by their attitudes and by a succession of curved angular gestures. The
angels also, in spite of the flame-like swirl of their wings and draperies
are an inherent part of the composition, unlike the hysterical swallows
that skim above later Crucifixions. It is also obvious that, as distinct
from most of the earlier work of the *dugento* and also from the art of
Giotto, outline is almost non-apparent; and there is little schematization
or crude ignorance in the anatomy of the Christ. Had he been born a
generation later, how easily would this artist have done away with
mediaeval tradition; yet what he would have gained in naturalism could
scarcely have compensated for the loss of crystallized pattern and of
decorative unity with the architectural interior.

It is important to remember that the similarity between the St. John
of this fresco and his counterpart in the apse mosaic of the Pisan *duomo*
(Fig. 14) was the clue which united the tradition of Cimabue's work in
the upper church with that Pisan document which mentions him ex-
pressly as the author of the St. John in the mosaic.[24] The likeness is
indeed impelling, and if this Crucifixion and other stylistically similar
works are not Cimabue's, some other painter of equal traditional repu-
tation must needs be found to take the place of one who was so evidently
worthy to hold the field of painting before Giotto.

The apse is devoted to the apocryphal legend of the Virgin. Bonaven-
tura's dictum may be translated in part as follows:

The Mother of the Lord Jesus Christ he held in unspeakable love, since it was
through Her that the Lord of Majesty became our brother, and we are followed
by Her mercy . . . and to Her honor he fasted from the feast of the Apostles
Peter and Paul to the feast of the Assumption most devoutly.[25]

Four scenes from her early life appear in the two topmost recesses. In the first (Fig. 15, upper) is an angel descending towards an old man seated before a flock of sheep. This is of course the "Annunciation to Joachim." The scene which I believe to be sequent represents the Nativity of the Virgin (Fig. 16, upper). Saint Anne is half reclining in bed beneath a canopy with an attendant beside her and two female figures to the lower left—doubtless midwives bathing the Virgin. Both Saint Anne and her attendant have been redrawn and repainted; but the following scene (Fig. 15, lower) has been so thoroughly done over as completely to confuse its iconography. It has usually been interpreted as Joachim's offering refused. But this does not explain the torch-bearing procession (all of which would probably not have been a later addition) nor its sequent position to the "Annunciation to Joachim" which it should properly precede. In its original state it more probably represented the convocation before the priest of Mary's suitors with their wands. But the restorer, besides completely refurbishing the faces, has apparently metamorphosed one of the suitors into an angel, added flames to the tips of the wands and distributed haloes, turning it into a sort of procession of saints and angels before their Lord. That the subject was originally the suitors before the high priest is supported by the final scene which unmistakably represents the marriage of Mary and Joseph with the dove alighted upon his bourgeoning wand. (Fig. 16, lower.) Though the other suitors have suffered restoration, this Joseph still bears the stamp at least of Cimabue's design, as do some of the other saints and angels ranking upon the arches that enclose these recesses and the apsidal windows, and decorating the arcades below the recesses. But below all these will be found those scenes from the death and glory of the Virgin which comprise some of the master's finest work.

These four lower scenes show many divergences from any known representation of the legend, and do not follow accurately any extant text. Yet the narrative as retold in the Golden Legend shows many analogies with these scenes, and is here taken as the closest and best known literary basis that can be found.[26] In the first section to the left (Figs. 17

and 17a) may be seen the Last Hour of Our Lady. She reclines on a brocaded divan beneath suspended lamps, and the apostles are arranged about her in a consecutively rhythmic composition which repeats the silhouette of her figure.

> Quand la Vierge vit tous les apôtres réunis, elle bénit le Seigneur et s'assit au milieu d'eux, parmi des lampes allumées.

The singularly grim saint standing to the right, with a scroll in his left hand and his right arm upraised, has heretofore always been identified as the Christ, who, according to the Legend, appeared at the third hour of the night to claim the soul of the Virgin. But since the crossed nimbus, the flowing hair, and the features of the Christ type are all lacking, the usual interpretation is unsound. Moreover, in Duccio's representation of the same scene, an apostle of the Paul type is to be found standing in much the same iconographical relation.[27] But little of the synthetic composition and grave import of Cimabue's scene appear in Duccio's version.

The next half-obliterated scene (Fig. 18) is only a slight revision of the conventional Dormition, so common in Byzantine and Italo-Byzantine iconography. Christ stands above the outstretched body of Mary with her soul, represented as an infant, in His arms. Encircling the deathbed are the twelve Apostles, and above them, amid angels, are a row of old men with hexagonally pyramidal caps, a group of old and young men with diadems on their foreheads, and a third group distinguished by haloes only. These three rows of witnesses may now be seen to better effect in the fresco following; and they probably represent the patriarchs, martyrs and confessors, who, according to the Legend, appeared from heaven in attendance upon their Lord.

A connection between the Legend and the conventional Dormition appears in the passage following:

> Et le chef du chœur céleste entonna: "Viens du Liban, fiancée, pour être couronnée!" Et Marie: "Me voici, je viens, car il a été écrit de moi que je devais faire ta volonté, ô mon Dieu, parce que mon esprit exultait en toi!" *Et ainsi l'âme de Marie sortit de son corps, et s'envola dans le sein de son fils*, affranchie de la douleur comme elle l'avait été de la souillure.

But not only the soul of Mary was to be exalted. Christ commanded the Apostles to bear the body of the Virgin to the Valley of Jehosophat, to depose it in a tomb which they would find prepared, and to await Him there three days. At the end of this time He appeared again before the Apostles and questioned them:

"Quel honneur pensez-vous que je doive accorder à celle qui m'a enfanté?" Et eux: "Nous croyons, Seigneur, que, de même que tu règnes dans les siècles des siècles, vainqueur de la mort, de même tu ressusciteras le corps de ta mère, et le placeras à ta droite pour l'éternité!" Et aussitôt apparut l'archange Michel, présentant au Seigneur l'âme de Marie. Et Jésus dit: "Lève-toi, ma mère, ma colombe, tabernacle de gloire, vase de vie, temple céleste, afin que, de même que tu n'as point senti la souillure du contact charnel, tu n'aies pas non plus a souffrir la décomposition de ton corps!" Et l'âme de Marie rentra dans son corps, et la troupe des anges l'emporta au ciel.

This Assumption appears in the following scene (Fig. 19). Four angels bear aloft the mystical ellipse in which is seated the Christ (whose remarkably fine head should be noted) supporting His fainting mother (Fig. 19a). Below are the three rows mentioned before, and below these, and now quite invisible on account of the choir-stalls, is the empty tomb surrounded by the Apostles. It will be noted that certain of the figures toward the ends of the rows turn their faces about and upwards to behold the miracle, thus helping to centralize the composition. This same motif had long since been realized to better effect by the sculptor of the twenty-four elders on the tympanum of Moissac, for instance, and appears also in the two outer prophets below the throne of Cimabue's Trinità Madonna. But the presence of Christ seated within the ellipse and clasping His mother as they are borne upwards is, to the writer's knowledge, unprecedented both in art and narrative, and adds a sense of restrained pathos and of dramatic actuality to the ancient theme.

The last scene of this series is not as we might expect a Coronation, but portrays the Virgin as mediator between humanity and Godhead (Fig. 20, details a, b, and c). Low to the left—probably representing the Franciscan Order—are the tonsured heads of many monks, whom Mary

indicates, half turning towards her Son. He acknowledges with His right hand the suppliants and bears the apocalyptic book in His left. The monumental throne extends far down behind the present choir-stalls and is flanked by the same heavenly squadron. Since this scene is comparatively well preserved and is in every way characteristic and worthy of the master, it serves as a good comparison piece between probable and improbable Cimabues. For instance, the three superb angels (Fig. 20c) to the right of Christ may be compared with the decorative angels in the upper parts of the left transept, and one will, I think, feel that those of the gallery (Figs. 5 and 21) though grandly monumental, are of the master's design only, and that those over the end wall (Fig. 22) bear still less the mark of his execution; while the heads from the Fall of the Dragon scene (Fig. 6) are unmistakably his own. Also the madonna and angels of this section should be compared with their nerveless counterparts in the Louvre "Cimabue"; and resemblances amounting almost to identity will be found between the prophets below the throne of the Trinità Madonna and certain of the patriarchs and martyrs of this and the preceding frescoes. But more of this hereafter.

The right transept is dedicated to the Apostles. According to Bonaventura—

> All the apostles especially Peter and Paul he held in the highest devotion for their fervid love of Christ. And because of his reverence and love of them, he observed a special fast of forty days.

The twelve Apostles, now mostly obliterated or in ruins, were set within the arcades, and scenes from the lives of Peter and Paul painted below. Beginning with the section to the right of the tribune (Fig. 23), one sees as the center of the composition an octagonal structure rather like a baptistry with a Roman portico.[28] Before this a bearded saint bends toward a seated figure. The scene could scarcely be other than that of Peter healing the lame man at the gate of the temple which is called Beautiful, as recounted in *Acts* iii. 1-10. Peter is accompanied by the beardless John and performs the miracle before a bewildered throng.

In the next section, before more fantastic architecture, are four saints drawn in Cimabue's strongest manner (Fig. 24), the foremost of whom casts devils out of a prostrate huddle of humanity. This scene, now almost completely hidden by an organ, has received various explanations. But an exact reference will be found in *Acts* v. 12-17, wherein Peter and other Apostles congregate on Solomon's porch and heal the sick and those vexed with unclean spirits who were brought to them.

Two scenes on the end wall obviously represent climactic moments in the apocryphal life of Peter. The first is the Fall of Simon the Magus (Fig. 25). As recounted in the Golden Legend, St. Peter, at the behest of Paul (to the lower left in the fresco) confounds the demons who bear Simon off a tower (here represented as a scaffolding) and commands them in the name of Christ to cast down the sorcerer, to the consternation of an enthroned and sceptered Nero and his retainers. The architecture behind the Emperor is certainly of Byzantine extraction.

The second scene on the end wall is the Crucifixion of Peter (Fig. 26). The Angels mentioned in the Legend stand to the right, and the compassionate throng to the left. The structure to the right is probably supposed to represent the fabled *meta* of the Roman circus with the terebinth tree here set at the top, and that to the left, though it should logically be the obelisk, was perhaps suggested by the pyramid of Cestius.

The last section of this group (Fig. 27) is badly effaced, especially in the lower and most important part of it. Yet the reasons for supposing it to have originally represented the Beheading of Paul are adequate. Near the lower edge and to the right of the center a segment of nimbus and part of the severed head are visible. Above this stands the executioner, and high above him, behind a rocky cliff and separated from the throngs that fill the mountain gorges, are the five soldiers mentioned in the Legend. It must also be remembered that the martyrdoms of Peter and Paul were always associated with each other, since they were fabled to have occurred in Rome on the same day.

The iconography for these scenes on the end wall, and perhaps even the designs, seem to have been taken from the corresponding frescoes

once within the portico of old St. Peter's, and copied in the seventeenth century by Grimaldi.[29] To judge from the two apostle heads that have survived the destruction of these frescoes[30] they appear to have been the work of the Roman school, not the early work of Cimabue himself; and though the problem is a confused one, it suggests that the frescoes on the end wall are not necessarily of Cimabue's execution—an assumption which becomes almost a certainty after close inspection. The difficulty and danger of comparing these sections with the others is of course increased by the fact that they have not oxydized in the same way from light to dark; yet this very fact suggests a difference of paint chemicals and technical procedure; and comparing the mobs in the two martyrdom scenes with any other mob in the choir or transepts, one will feel the distinction between mere rudeness and rigorous structural calligraphy. Moreover, the figure of the crucified Peter is a sorry makeshift, while his ministrant angels have the quality of imitation angels. And in "The Fall of Simon Magus," Nero and his retainers are Cimabuean in gesture only. This group, however, if it has not undergone repainting, is an interesting one, and suggests, especially in the figure to the left, an impressionistic style. But on the whole these scenes appear to have been the work of one who was vainly attempting to imitate the style of Cimabue.

Even more problematical is the second great Crucifixion covering the east wall of this transept (Fig. 28). The presence of two Crucifixions placed especially for the edification of the Brothers as they performed the mass is quite explainable on consideration of the Franciscan emphasis of the Crucified. Moreover, the moment here represented is slightly anterior to that of the other Crucifixion. For, in accordance with the ancient motif, the spear and sponge bearers are seen simultaneously at their tasks. The problem lies rather in the attribution of this Crucifixion and in its date of execution with regard to the rest of the work. To begin with, one must acknowledge that the Virgin is repainted. Not only does she differ completely in style from the mass of Cimabuean women behind her, but the summary relining of her features also betrays the work of

some casual restorer. Yet, even so, the difficulties are far from solved. Enough can be seen of the Jews to the right, of the angels, and especially of the women behind the haloed group to the left (Fig. 28a) to suggest that it was in part the work of Cimabue. But the astounding composition of the other Crucifixion, the formidable solidity of its figures, and the great swirl of angelic wings and draperies are wanting, and the Christ has now the appearance of a brutal parody. Though any dogmatic verdict from what remains would be futile, it is strange that the least important figures seem best in execution.

But if much of the lower work in the right transept is of Cimabue's design only, that in the upper parts seems even less closely related to him. The arches here are set with great rosettes, large geometrical designs, or free swirls of foliage as in Fig. 29—an ornamental scheme far bolder and less complicatedly stereotyped than anything else in the upper church, and reminding one of the more ancient decorative strips still visible in the nave of the lower church. Though it is difficult to guess at the original colors, green and black now predominate, and contrast strongly with the ochres and azures of the left transept. This contrast is in every way greater and the work finer than the most arrogant of restorers could have achieved.

In the topmost recess of the east wall is a Transfiguration (Fig. 30). The recess opposite must originally have been filled with the Apocalyptic Christ surrounded by the symbols of the Evangelists, but now only the beast of Luke, set conventionally to the lower right, is visible. Flanking the windows of the end wall are the colossal figures of a patriarch (?) and a sainted king, perhaps David (Figs. 31 and 32). In spite of its strong calligraphy none of this work has much in common with Cimabue's style as we know it in his best authenticated work. The "patriarch," for instance, shows little of that structural pattern we have associated with Cimabue; his hair is not a wispy leonine mane, his eye sockets are not sculpturesque, shell-like concavities. The argument that this may have been an earlier work of the master's cannot be completely refuted; but

to make such an admission is to grope in the dark, and to confuse the peculiar qualities of the body of work which is inevitably his.

Considering the many contrasts between the decoration of this upper right transept and the rest of the decoration throughout the church, one may be led to the conjecture that this was the earliest work in the church, and that Cimabue, aided by the Roman ornamentalists with their conventionalized foliation, their medallions and illusionistic mouldings, determined a scheme of decoration which, so far as its color and obvious ornamental effect is concerned, was perpetuated with few alterations in the nave.

So much for a bare account of these frescoes. It will have been noted that the following works have here been attributed to the comparatively unaided execution of one master, who, we have every reason to believe, was the Florentine painter Cenni di Pepi called Cimabue—the four Evangelists, the Apocalyptic and lower Virgin scenes, the two scenes from the life of Peter on the west wall of the right transept, part of the Crucifixion in the right transept and of course the Crucifixion in the left.[31] And it is these works, combined with others which seem to the writer inevitably to belong to the same master, that will be taken as a basis for the consideration of the aesthetics of this artist and of the influences which helped to determine his art.

### III

There are at least four fundamental relations that mural painting may have with the architecture that encloses it: (1) It may have no relation except that imposed by the exigencies of wall space. (2) It may create the illusion of a new architectural effect. (3) Its pattern may repeat with variations the architectural outline of its wall plane. (4) Its pattern may seem three dimensional and repeatedly suggest with infinite variations the aesthetic qualities of the architectural enclosure—such as its lines, its masses, its volume, with their humanistic associations.[32]

The first of these relations, or rather the lack of any organic relation,

does not need to be explained; but one should not infer that the lack of it precludes decoration of the highest quality. No one would vitally associate the frescoes of Masaccio with the architecture of the Brancacci Chapel or with the Gothic church in which this chapel once stood. Masaccio was not an architectural decorator in the sense here implied. His unit was the monumental composition of each fresco. In fact one may say that this artist's preoccupation with the inherent significance and real appearance of things precludes architectural decoration.

The second of these proposed relations is classically illustrated by the manner in which Michelangelo shattered and pilastered the ceiling of the Sistine Chapel to remould it nearer to his baroque desire. And after him the deluge. A studied observance of the third relation is evident in most of Raphael's work in the Vatican. Here, however, the wall plane is also used as a window; and this common use may seem at first to imply an additional relation, but is really included in the others. Naturally all mural painting shows a mixture of relations, the question being which one is predominant.

The fourth, with which we are chiefly concerned, is partially exemplified in the Arena Chapel at Padua, and in the choir and transepts of the upper church. This conception may easily be misunderstood and is difficult to explain. But consider one who has studied Giotto's frescoes at Padua from photographs only. For him it is obvious that the figures emphasize bulk and that the masses often assume admirable compositions. Something of the permanency of the rocky backgrounds, the solidity of many of the figures and the relaxed flow of others is also apparent.[33] Moreover the illustrative value of these photographs—actions and emotions common to all flesh, simply, broadly and at times poignantly represented—these may evoke more than a perfunctory admiration. Yet he will be quite unprepared for the total effect of the Arena Chapel.

That the extraordinarily heightened effect is due in part to the coloring of the chapel and to the increased sense of scale are irrefutable though inadequate arguments. In all the greatest *quattrocento* fresco decoration,

for instance, the disparity between the aesthetic effect of the photographs and the originals is by no means so overwhelming. The most satisfactory explanation seems to be that the frescoes of the Arena Chapel inevitably *belong* within their architectural enclosure as an integral and, as it were, organic part of it. The lines and volume of a bare oblong hall surmounted by a barrel vault are not aesthetically stimulating; they induce on the contrary a sense of repose, of the simplest harmony, perhaps of monotony. But imagine such an interior decorated with scenes in which the figures and their grouping reiterate this simple architectural harmony with rhythmic variations—this is to realize one of the aesthetic essentials of the Arena Chapel. A conception of these figures as so many barrel vaults seen from without would be absurd and painful, though instances might be given (such as the forms of the two central women kneeling over Christ's body in the Pietà) in which this is literally true. But my contention is that these figures, whether static or in rhythmic sequence, lend a harmonious animation to the lines of the interior (here accentuated by ornamental strips) and to its volume. Many passages are of course in themselves remarkable, but the particular, instead of distracting the attention from the total effect, helps to complete the sense of aesthetic unity. It should also be noted that, although enough space is suggested in these scenes to contain the figures, they are held within the chapel, and one's gaze is not projected into the void. Thus Giotto here instinctively developed what might be called mediaeval architectural decoration to its limit, and in this he had no followers. In fact, Cimabue may be thought of as the only other great exponent of this theory in Italian painting; but whereas in the Arena Chapel the visual verification may still be made, in the upper church the original effect must be largely inferred.

The distinction between the aesthetics of a barrel vaulted and a Gothic interior is obvious. Instead of repose there is (for anyone not wearied of groined vaults ancient and modern) stimulation, a sense of springing exultance, a sight of intersecting lines binding masses which are known to conform to a geometric and structurally balanced design.

The construction of the upper church shows little of the mechanical virtuosity of advanced French Gothic; but the aesthetic qualities of its interior are more immediately comprehensible, since the design is simple, the height of the vaults not vertiginous, and the rib structure heavy and accentuated (Fig. 33). It has already been suggested that the figures of the four Evangelists seem an integral part of the vaulting. And this is literally true; for the curved angles with their surfaces, which have been shown to be the basic structural pattern of these figures, are the same as the curved angles of the vault structure, and repeat its lines and masses with live variations. One of the chief distinctions between Cimabue's art and the best surviving Byzantine is that his figures, with all their firmer geometrical unity, are more representationally alive. A synthesis between pattern and representation is a preliminary requisite of all great visual art and, if rightly understood, should occupy a position very near the center of aesthetic theory; but there is here the additional synthesis with the architecture—a quality which has often been noted in the sculpture and *vitraux* of the Romanesque and Gothic north, though in a more obvious sense than that implied here. This last point, however, is important and will reappear later. But here the reader must be assured that I do not propose that Cimabue was conscious of any such theory of architectural decoration. Though it is of course impossible to know his attitude towards his work, he probably felt that this was the right way to fill a vault with these traditional figures, and in so doing he followed an instinct which is now so completely lost that most moderns have difficulty in realizing the total effect—to say nothing of creating its equivalent. But when the sense is once grasped, one has only to compare these figures with the four Church Fathers in the end vault of the nave in the upper church to know the difference between architectural decoration, as the term is here used, and technically proficient church painting. For although the slightly bent figures of the Fathers within their Cosmatesque settings of necessity conform to the spaces in which they are set, their structure is not that of the vaults,

and the angular ripples of their drapery are too insignificant to be anything but ornamental.

It would be unnecessarily tedious to point out at length the repetition of curved and structural angles in the sections below. But if the reader will apply himself closely to the reproductions and imagine them within a comparatively low Gothic interior, or better, if he will visit the upper church and mentally repaint these scenes in harmony with the choir vault, so that the figures regain something of their original accent, then he may reach the conclusion that these also produce a strong sense of architectural decoration.

Moreover, several of the sections with their closely packed groups below, which indicate by look or gesture the logical focus of interest in the upper center, have what might be called a pyramidal focus, and one's gaze is naturally directed upwards as it should be within a Gothic interior. The most successful exception is the scene presenting the last hour of the Virgin, in which the monotony of the rectangular frame has been relieved by a low trilobate arch painted above the figures. The rhythmic grouping of the Apostles about the Virgin has already been noted, but the swinging line of this group combines with the painted arch above it into a masterpiece of surface composition. And even here the arch, though self-contained, is by no means out of harmony with the Gothic.

But more important than obvious matters of surface composition is that aspect which has already been insisted upon—the architectural quality of the figures. That the Gothic vaulting with its vista of curved angles and its inverted concave pyramids formed by the ribs and web curving upwards from the imposts—that these lines and masses should be translated into figure art or at least in some way coincide with it may seem at first fantastic; but to the writer it is a clarification of experience, and may no one think that he wishes to impose a frigid *a priori* critique upon frescoes already sufficiently damaged by time. If one imagines a constructive genius whose sense of the aesthetic and structural impact of a Gothic interior was fresh and keen, some latent psychological connec-

tion between the architecture and the decoration will not seem improbable. And if the reader will study the figures in those scenes here attributed to Cimabue until his eye and brain are as it were saturated with their typical geometry, he will find in them little more than variations on the pattern proposed, and may feel that there is no other type of architecture conceivable in which they would so inevitably belong. It is sufficient to imagine these frescoes transferred to the Arena Chapel or *vice versa* to realize what would be lost in either case. That the total effect of both these interiors was to some extent a happy coincidence of the inherent temperament of the artist with the aesthetic appeal of the architecture cannot be denied. It is, at least to the writer, inconceivable that Cimabue would have painted the Arena Chapel as well as Giotto; and the work of this master and of those who approximated his style in both upper and lower churches at Assisi show at best only a superficial relation with the architecture. Yet that this synthesis was in both cases mere coincidence seems also inconceivable; and the following corollary suggests itself: that both Cimabue and Giotto required an architectural interior harmonious with their own natures to evoke their fullest expressions. Thus while stimulation is probably one of the most natural qualities of Cimabue's art, Giotto's at its best suggests repose—or rather a simple and vital composure. And these two artists, otherwise so apparently divergent in spirit, had in common this supreme sense for architectural decoration. It should also be remembered that the peculiar excellence of their art was partly the result of the fortunate technical limitations of their times. For the gradual conquest of naturalism, that mistress of all the great periods of western art, who was so inspiring to pursue and so deadly to possess, soon made this sort of decoration impossible. And had Cimabue or Giotto lived two hundred years later, they would probably have painted away the walls and, being architecturally minded, have created a new structural effect.

Yet the term "decorator," use it as you will, does not connote the full meaning of their art; and we have already seen something of the illustrative power and emotional temper of Cimabue's work in the upper

church. But in what sense may he be considered an innovator, and what qualities are essentially his own? For although the cult of individualism, in its modern sense, is happily unthinkable in this relation, genius implies a certain amount of individuality. To answer these questions, no matter how inadequately, we must first consider broadly and in as brief a space as possible the relations between his body of well authenticated work and the art traditions of his age. For, like most art of permanent value, Cimabue's was conditioned though not strictly determined by the conflux of several strong tributary traditions, and if a further attempt to suggest them were neglected, this study would be quite incomplete.

## IV

The decoration of churches in fresco seems to have been comparatively rare in *dugento* Tuscany;[34] and its one remaining monument of extensive mural decoration is the mosaic work of the Florentine Baptistry. These mosaics are of interest on account of their proficiency as late Byzantine craftsmanship,[35] and because of the certainty that Cimabue was acquainted with them, and the possibility that he assisted on the lower rows as other writers have already indicated. Indeed, in such a section as that representing Zacharias taking down the name of the infant John (Fig. 34), the head of Zacharias, and especially that of the youth to the upper right of the attendant group show more than the usual Byzantine approximations of Cimabue's style. But unless this section could be shown to date from the master's early years, when he might have been employed as a minor assistant, there is no good reason for attributing any of this work to Cimabue himself. And while there is a show of animated composition in certain of the other sections, especially in the Passion scenes, it is difficult to see how these could have been an essential inspiration for anything peculiar in the art of Cimabue's maturity.

The wooden altar-piece and crucifix, however, demanded neither the expense of mosaic nor the forthright brushwork and large conception of the master painter in fresco, and to consider extant Tuscan examples,

even in brief, would require at least a separate volume.[36] If a large number of these are studied until their obvious resemblances are taken for granted, their diversities become ever more apparent. At times the assimilation of the purest Byzantine tradition—its standard hierography, technical perfection, richness of detail and usual lack of humanistic content—is complete; but this is commonly mixed with the rude vigor or mere incompetence of the Tuscan artisan, and often with evidence of his diverting or strangely appealing attempt to represent actions and emotions incompatible with the ideal of an unearthly icon. And these qualities are to be found in every conceivable combination. The result is sometimes the feeble or ugly imitation of effete formulae; and perhaps when the glamour of novelty has worn from this period many of its works will be recognized frankly as bad art, and as not necessarily "primitive" in the best sense. For it is obvious that the art of this place and time should be subjected to a discrimination at least equal to that applied to later Italian painting. On the other hand, a fresh vitality working in ancient forms at times realized the stiff strength and representational purport of a primitive art of high significance, disciplined and nourished by tradition. And it is this combination that Cimabue's Trinità Madonna (Fig. 35, details a, b, c, and d) so miraculously represents.

There are no extant prototypes to the composition of this altar-piece—the conventional presentation of the subject having been the Virgin and Child enthroned with two angels in the upper corners and with or without scenes from the life of the Virgin in side panels. Approximations in facial modelling, however, may be traced to various Tuscan examples.[37] But aesthetically speaking one of the finest prototypes to the Trinità Madonna is the panel usually attributed to Coppo di Marcovaldo in the Servi in Orvieto (Fig. 36).[38] In both of these paintings the richness of detail, though elaborate, is subordinated to a firmly unified schematization, the pattern of the Orvieto work being more circular and less angular than that of Cimabue.[39] More remarkable, however, are the faces of the Madonna, which—to say nothing of certain loose analo-

gies in the modelling of the features better seen than described—have neither the hard dogmatic grimness of barbarous work, nor the inert impassivity of the typically late Byzantine, but already suggest with nobility and restraint the profoundly human emotions with which the Mother of God was popularly endowed.

But although the work of Coppo, if he was indeed the master of the Orvieto Madonna, gives rudimentary evidence of the spirited intelligence that was to make Florence the center of Italian humanism, this altar-piece does not rival the Trinità Virgin Enthroned. There is perhaps no other panel to which the term "monumental" may be more justly applied. The great throne gives a basic structure, and the flanking angels are firmly composite in angular rhythms which culminate towards the head of the Virgin.[40] It may be contended that without the figures beneath the throne the composition would be better balanced and welded; yet few could wish the omission of these portentous elders or of their hieratic purport.[41] The body of the Virgin is undeniably flat, and suggests that this panel antedated the Assisi frescoes; but her face, with its broad brows and incisive modelling, has not only the structural schematism peculiar to Cimabue, but an expression not easily defined, to which one is drawn with unwearying delight. Beside her the Rucellai Madonna, for all her perfections, seems an exquisite symbol, and Giotto's great Virgin in the Uffizi a fertility goddess of the earth overburdening her fragile throne. But in the face of the Trinità Madonna, as she proposes her still dogmatic Child, there is a spiritual subtlety and psychic awareness not to be explained away as a modern interpretation of a chance effect.

The frescoed *Hodegetria* with St. Francis in the lower church in Assisi (Fig. 37) is the only other work of this type which may with some certainty be assigned to the master's execution. But it has lost most of its quality through repainting, and what remains of the original adds nothing to our conception of the master's art.

But the Louvre panel (Fig. 38) deserves fuller comment, since it and the Rucellai Madonna are chiefly responsible for what the writer be-

lieves to be a false impression of the essential character of Cimabue's work. Most obvious of course, in the Louvre painting, is the frigid adherence to the master's design, especially in the figures of the Child and the angels. Yet the influence of the Rucellai Madonna (Fig. 39), here considered antithetical to Cimabue's art,[42] is also apparent, especially in the head and expression of the Virgin, and in the attitude and modelling of her right hand. The lightness and laxity of the structure also suggest this misconceived influence, while the Cimabuesque angels are dry, dour, and lifeless. It is, to say the least, quite unlikely that Cimabue himself would have been largely responsible for the execution of a panel of such methodical and eclectic deadness, especially since all of his better authenticated works, from the early Trinità Madonna to the St. John mosaic, show a uniform and powerful aesthetic. Moreover, the seated posture of the Louvre Virgin is more obviously represented, and this, combined with the stereotyped quality of the whole panel, suggests a later dating than any that may be assigned to either the Trinità or Rucellai Virgins. Thus the Louvre painting is more readily explained as the work of one who proficiently followed in great part the master's design, but who lacked his sense of dynamic construction, and borrowed incongruously from the ever popular Rucellai Madonna.[43]

The numerous wooden crucifixes of the period testify of course to a Franciscan impetus. And though the change from the Christ Triumphant to the dead or agonizing Christ was Byzantine in origin, it coincided well with the new spirit.[44] One of the earliest and finest examples of the Franciscan cross must have been that which Giunta Pisano painted for our basilica at Assisi.[45] To judge from the two or three surviving crosses which may safely be attributed to him, and also from the fact that Brother Elias before his deposition took every measure to secure the best for his basilica, one may think of Giunta as at least one of the foremost painters of his time. Furthermore, it is natural that such an artist should have appeared in Pisa in the first half of the *dugento*, since this city was then at the height of its power and held extensive trade com-

munications with the East. Especially his small crucifix in Santa Maria
degli Angeli below Assisi is the work of a finer and more vigorous artist
than the usual painter of wooden crosses, and the tragic significance of
the theme is not perverted by misplaced refinement or grotesque and
overschematized distortion. Yet, except for the rehandling of late Byzan-
tine formulae to nobler ends, no specific connection between his work
and Cimabue's is now apparent. There seem, however, to have been few
*dugento* crosses of great aesthetic consequence,[46] and since our considera-
tion of Tuscan painting is limited to its application to the art of Cimabue,
we may turn to the cross in San Domenico in Arezzo (Fig. 40, details
a, b, and c). Here the ancient pattern assumes the hard modelling of
wooden sculpture, the technique is firm, and the Christ is a stricken god.
A close comparison between this Christ and what remains of His coun-
terpart in the great Crucifixion of the upper church will reveal far more
than traditional resemblances, and if the cross of San Domenico is not
a comparatively early work of Cimabue's, it is the creation of a master
of similar style and equal potentiality.[47]

The total effect of the well known Crucifix of Santa Croce in Florence
(Figs. 41, details a and b) is, on account of its attenuation and softened
modelling, not so powerful; and its particular degree of authenticity is
largely a matter of personal opinion. Yet considering its traditional at-
tribution and the strongly Cimabuean imprint of the face of the Christ,
one may think it, at least in part, a comparatively late work of the
master's, executed at a time when the aid of assistants might be taken
for granted. Moreover, beneath its softened surface will be found an
anatomical schematization identical to that of the Arezzo Crucifix.[48]

As an iconographical prototype of Cimabue's scenic Crucifixion that
of the so-called Master of St. Francis in the lower church has already
been suggested. Nicola's presentation of the subject on the pulpit of the
Pisan Baptistry, executed about 1260, should also be mentioned as the
first datable scenic Crucifixion of the period. Such general similarities
of iconography, however, as the terrified group of Hebrews, one of whom

clutches his beard, are not sufficient to proclaim it as the direct source of Cimabue's inspiration.

## V

The influence of Rome upon Cimabue—its architectural monuments and its ancient traditions of church decoration in mosaic and fresco, which seem to have undergone a brief revival during the last quarter of the *dugento*—is now largely a matter of speculation and inference. It should be remembered that in 1272, the one documented date discovered to prove our painter's presence in this city,[49] Cavallini, who is conventionally considered the leader of the Roman revival, must have been a mere youth, if the commonly accepted date of his birth is approximately correct. Moreover, his first works that can be dated with some probability—the frescoes originally in St. Paul's Outside the Walls— were apparently executed about 1285, while none of his extant works can be dated before 1290. Of course one cannot tell how long Cimabue stayed in Rome, and he may well have returned there later; but there is no evidence that Cavallini or any other contemporary Roman painter contributed anything essential to his art. On the contrary, there is every indication in several sections in the nave of the upper church in Assisi that he influenced some of them.[50] Also Cosmatesque ornamentalism apparently did not interest him, nor the superficial Gothicism of Arnolfo di Cambio.

Yet Rome was the only city in Italy where traditions of ecclesiastical wall painting had persisted, with many relapses and changes, since the time of the Catacombs; and the amount of contemporary and ancient fresco work visible in Cimabue's day must have been overwhelming. Even its qualities cannot be judged with any certainty, since so much of what remains is to be found either in crypts or in small out-of-the-way churches not considered worth renovating—places that would not necessarily have drawn the best artists of their day. His probable adoption of certain designs from the portico of Old St. Peter's—executed at Assisi chiefly by an aid—and his representation of Roman architectural

monuments in one of the sections of the choir-vault of the upper church have already been mentioned. Also the finely classical portico in Fig. 23 deserves renewed inspection. Thus one may think of Rome as offering a stimulus to Cimabue's structural genius and a precedent for fresco work on a large scale; but if his mastery of architectural decoration or the peculiar spirit which informs his work ever existed in Rome, they are no longer to be found there.

It is commonly said that the sculptural and glass decoration of northern cathedrals and churches was auxiliary to the architecture. And this statement is especially applicable to the best artisanship of the advanced Romanesque and early Gothic periods. At Chartres, for instance, it is obvious that the columnar and attenuated figures about the portals emphasize the vertical lines of the Gothic—a motif which is not to be explained away by the argument that little was then known of anatomy and that the flesh was theoretically despised. The Romanesque or Franco-Byzantine figures of the west portal are almost completely architectural, and though the heads of the thirteenth century figures of the north portal are more individualized, their bodies remain columnar. Similarly the sculptures of the lintels, the tympana and the voussoirs are all subdued to their architectural setting. The glass within assumes an immediate and obvious effect of architectural decoration on account of the narrow and pointed shape of the typical window. But more than this the designs fill their frames and are contained within them, without scenic effect; and if one will compare the full-length figures in the windows of the clerestory and high in the choir and transepts with good Byzantine work, such as the prophets at Daphni, one may see that the figures at Chartres, though derived chiefly from the Byzantine, are already French and adapted to a new architecture.

An analogy between this and Cimabue's transformation of Byzantine design will be obvious, with the important difference that the work at Chartres was on a far vaster scale, and what unity it possesses was effected by the communal constructive spirit of several generations of

master builders and great artisans, whereas the decoration of the choir
and transept of the upper church was largely the construction of one
individual, whose sense of aesthetic organization would be rare enough
at any time. The analogy, however, is not confined to an intellectual
concept of architectural decoration, but is also to be found in an emo-
tional ardor and versatility. The art of France in the thirteenth century
has been called savage, exquisite, serene, naïve, nobly human, sublime
—almost anything except dead; and sufficient examples could be cited
to justify the use of any of these adjectives or many others in diverse
combinations. All of which is merely to say that this art reflected the
many qualities of a race during an intensely animated period of its his-
tory. Of course it is unthinkable that the emotional diversities of a cen-
tury of master artisans should appear in the work of Cimabue. Yet in
his reanimation of Byzantinism—as witnessed for instance by the feroc-
ity of his Hebrews in the Crucifixion, the noble virility of his Christs,
the grimness of his patriarchs, and the strangely vital beauty of his
angels and Madonnas—there appears more than a symbolic presentation
of the contrasts of mediaeval imagination and experience.

The transforming Gothic influence, however, is not apparent in the
figure types of Tuscan painting until after the turn of the century; and
whatever relations existed between Cimabue and the northern workers
in stone and glass seems to have been the spiritual or biological affinities
of racially coeval artists, who had to some extent the same materials of
tradition to transmute into new idioms. But the art of Cimabue gives
stricter evidence than theirs of its strong Byzantine derivation.

Although Byzantine church art seems markedly homogeneous, if one
considers the broad geographical areas which it covered through many
centuries, yet most of the civilizations which accepted it contributed
something to the emotional or aesthetic appeal of the ancient ecclesiol-
ogy, nor was Cimabue by any means the first to animate the intellectual
concepts of the Church with some show of dramatic actuality. But the
usual Byzantine way of heightening the emotional pitch was either

through the splendor of material and intricacy of ornament, or through the exaggerated postures and expressions of unsubstantial figures. And in spite of exceptions to this rule which will occur to any scholar of the subject, the writer has found scant evidence, either in mural decorations or miniatures, for tracing the direct stylistic influences upon Cimabue's art to more remote sources than *dugento* Italy—especially Tuscany, which was at that time so thoroughly permeated with the art traditions of Constantinople.[51] One may, however, say that Cimabue, in his technique, retains a purer tradition of eleventh and twelfth century Byzantinism than was at all common among his thirteenth century compatriots.[52] This distinction is to be found in his incisive modelling of faces without the use of meaningless broad lines or splotches of color, and in his excellently understood use of hatching and of sculpturesque gashes in drapery. Also the Evangelists of the Assisi vault show, in their specific postures and occupations, direct analogies with the frontispieces of Greek gospels, and these would have been the most obvious miniatures to present themselves to Cimabue's inspection. But it would be difficult to find any that are aesthetically comparable to Cimabue's figures.

Thus, while his work retains much that is Byzantine in its schematism and elaboration of hieratic detail, its pattern is at once more geometrically consistent and more functional, and the representational value of his art is by no means subdued to mere pattern or to the sumptuousness of the medium employed. A certain affinity between his figure art and that of the most vigorous Chinese has already been suggested, and appears in his control of a pattern to evoke the beautiful, the dynamic, or the grotesque.[53] Yet contrasted with most oriental figure art, whether of China or Byzance, that of Cimabue is more intent upon structure and seems, at least to western eyes, less sensuous and mystical, and more rationally substantial.

## VI

The questions—what manner of man was Cimabue, and what is his ultimate position in Italian art—can receive no final answers. Dante's

early commentator, writing about thirty years after the painter's death, speaks of him as an arrogant being, and as a destroyer of his own work, if it displeased either his critics or himself.[54] Although this sounds like conventional comment on genius by one better fitted to recognize its vagaries than its capacities, it may not be altogether mythical, and might even be taken for granted on consideration of the combined power and sensitive precision of his work. Furthermore, it is difficult to conceive of anyone painting, or at least designing, his great Crucifixion, for instance, without displaying that impetuous precision with which Michelangelo is said to have struck animation out of a stone, in order to materialize his vision before it should fade. And perhaps it is not too fantastic to think that Cimabue was possessed and impelled by a not dissimilar creative and constructive *daemon*. But Michelangelo, as everyone knows, was born to progressive disillusion regarding the state of man, whereas Cimabue, whatever he may have been aware of, lived at a time when the Christian epic was treated with revived conviction. A sense of futility is not evident in his work, and he mixed pity and exaltation with his terror.          *6926*

Any imitation of Cimabue's style on a large scale would have been at least as disastrous as Michelangelesque imitation. With few exceptions, whenever his direct stylistic influence is evident, his sense for the strongly schematized grotesque becomes crude caricature, and his vital beauty, uncompromised by any facile charm, becomes inert, dour, or gracile. He developed his peculiar idiom to its logical conclusion, and few could have approached the height of his argument. Moreover, the time was ripe for a closer observation and portrayal of man's common inheritance—the earthly and obvious. Thus the change for which the Romanized Giotto was so greatly responsible was both fortunate and inevitable. And though this by no means adequately explains the aesthetic greatness of Giotto's art, it does much to explain its immediate popularity. But it was the overwhelmingly stimulating influence of Cimabue's accomplishment which must have incited his late contemporaries, especially Giotto, to excel in other ways.

# NOTES

[1] For a summary of the documents and of the legend from Dante to Vasari see Appendix I and II.

[2] Thode in his *Franz von Assisi* (1885) was the first to publish an intelligent appreciation of Cimabue's frescoes at Assisi. Strzygowski's conclusions in *Cimabue und Rom* (1888) may be questioned, but his discovery of the Roman document and the inferences to be drawn from it regarding Cimabue's development as a painter are important. Early twentieth century scepticism was induced chiefly by the disillusionment regarding the over-discussed Rucellai Madonna, and was largely dispelled by the one clue emphasized in Aubert's *Cimabue Frage*.

[3] The word "aesthetic" is now vague and has lost its innocence through the sophistries of metaphysician and aesthete. "Aesthetic experience" here connotes merely that interplay of mind and emotion induced by the *sight* of a work of art. Both the so-called "purely aesthetic" and those "representational" values which help to fulfil its meaning as a work of art are included in the phrase. Any exact distinction between what is and what is not a work of art is left to the reader's discretion. "Archaeology" is used in its most inclusive sense.

[4] After visiting the church in 1563 Vasari writes of the Virgin scenes in the apse as *"hoggi dal tempo e dalla poluere consumati."* Frey Vasari I, p. 395.

[5] Mr. A. M. Friend has pointed out to me many close iconographical analogies, which are especially applicable to the Greek Constantinopolitan types of the twelfth and thirteenth centuries—thus demonstrating another link between Cimabue and his Byzantine antecedents. The association of various parts of the ancient world with the Evangelists (to Matthew Judea, to Mark Italia, to Luke Ipnacchaia or Greece, and to John Asia) is made in each of the Monarchian Prologues to the Vulgate Gospels as published in Wordsworth and White *Novum Testamentum Latine.*

[6] For discussions on the construction of the basilica see Thode, pp. 184–214, Frey Vasari I, pp. 536–47, A. Venturi, *La Basilica di Assisi*, Turin 1921, Kleinschmidt, Vol. I, and Supino, pp. 13–55. Though at times widely divergent in their conclusions none of these writers dates the present walls of the upper church later than four or five years after the dedication of the basilica by Innocent IV in 1253.

[7] Four shields bearing the S.P.Q.R. insignia are also visible on this basilica, which is Cimabue's version of St. John in Lateran. The structure in the center is obviously intended to represent the Pantheon, and that to the left the Torre della Milizia, the topmost section of which is today no longer standing. Strzygowski's identifications (pp. 87 ff.) of the monument in the right foreground with the Mole of Hadrian and of the church behind it with Old St. Peter's are not very convincing, though the present writer has no better suggestions to offer.

[8] During his pontificate, Nicholas IV issued eight bulls towards the interests of the Franciscans in Assisi, granting them rights and gifts and proclaiming indulgences to pilgrims. (See Padre Angeli, *Collis Paradisi*, etc., Montefalisco, 1704, pp. 38–44.) In one of these, dated the Ides of May 1288, it is proclaimed that money should be raised for both the Basilica of St. Francis and the Portiuncula for drastic if vague innovations—*"facere conservare, reparari, aedificare, emendari, ampliari, aptari, et ornari praefatas Ecclesias."*

[9] The earlier dating, however, has been almost unanimously accepted by other writers on the subject. Unfortunately, the date of 1296 which Van Marle, Vol. I, p. 461, found in the gallery above the passage leading from the apse into the right transept is meaningless, since it is a

mere scratch and not an imprint in wet plaster. It has every appearance of a recent and scholarly hoax.

[10] There are no extant prototypes in church decoration for this particular apocalyptical cycle, for the Virgin scenes as here presented, or for much of the remaining decoration. To what extent suggestions were derived from miniatures remains uncertain; but, as will be shown later, some such influence on the apocalyptic scenes, no matter how superficial, is obvious.

[11] Those on the end wall are in ruins and the frieze on the outer surface of the east gallery has almost completely disappeared. The decoration of the recess above this gallery is too ruined to hint even of its iconography, though remnants of angels' wings are still visible. But the angels of the west gallery (Fig. 5) and several medallions on the arch over the end wall are in a fair state of preservation, and will be considered later in a different connection.

[12] Compare *Legendae Duae*, Chap. IX, sec. 3.

[13] These interpretations of the lower scenes throughout the apse and transepts differ only in a few instances from those of Kleinschmidt, who has largely corrected the accounts of other writers on the subject. But in this study additional iconographical sources and variations are suggested.

[14] The words IO(AN)NES and PAT(MOS) are still decipherable beneath.

[15] Thode, p. 230, n. I.

[16] Below this section to the left ANGELUS DO(MI)NI DESCENDE(N)S DE CELO is just legible and to the right FLEBIT DRACON. The lacuna between these remnants of legends is a broad one; the first probably refers to the angel in the Fall of Babylon, and the second to the Michael and the Dragon scene high above.

[17] Ideoque alterius *amici Sponsi*, Apostoli et Evangelistae Ioannis vaticinatione veridica sub similitudine Angeli ascendentis ab ortu solis signumque Dei vivi habentis astruitur non immerito designatus. Sub apertione namque *sexti sigilli vidi*, ait Ioannes in Apocalypsi, *alterum Angelum ascendentem ab ortu solis, habentem signum Dei vivi. (Legendae Duae,* Prologue, pp. 2 and 3.)

[18] For illustration see E. Mâle, *L'Art Religieux du XII^me Siècle, en France,* p. 5.

[19] For instance St. Michael is often shown accompanied by two assistant angels—a fact which makes Thode's suggestion (p. 232) that these symbolized the three Orders of Franciscans overthrowing the dragon of heresy irrelevant. Various representations of John on Patmos, the Fall of Babylon, and the Four Winds were also common in these northern miniatures, though none that I have been able to see suggest close prototypes for those here considered. For the most recent study of apocalyptic cycles see Montague Rhodes James, *The Apocalypse in Latin,* Oxford, 1927.

[20] For source information regarding conditions and beliefs within the Order during this period, and an intimate view of the times, see especially G. G. Coulton's incomplete but sufficient translation of Salimbene's Chronicle in his *From St. Francis to Dante* (London 1906), which includes illustrations from other sources and a good bibliography.

[21] The fanatical Franciscan Ubertino da Casale in his *Arbor Vitae,* written about 1305, speaks thus of his Mother Church: "Sic et carnalis ecclesia ex similibus operibus evangelicam vitam in reprobum sensum et Babylon meretrix pessima nominantur."

[22] Nicola Pisano's Crucifixion (1260) in the Pisan Baptistry should also be considered in this connection since it is the earliest datable Italian Crucifixion in which the presentation of the subject as a dramatic scene is achieved. But the analogy between Nicola's and Cimabue's presentations of the theme does not seem to the writer to be as close as Aubert (pp. 36–7) implies, nor can he entertain Aubert's opinion that Nicola's Crucifixion is mere "*Studienwerk*." For an account of the development of the Crucifixion into a dramatic scene see Millet, *L'Iconographie de l'Evangile,* pp. 444–8.

[22] There is no evidence that the painter tried to adhere strictly to the pseudo-Bonaventura account of the Crucifixion (*Meditations*, Chap. LXXIV); but the influence of this writer's power of emotional revisualization is possible. He makes frequent mention of the savagery of the Jews, becomes lyrical over the grief of the holy women and St. John, and speaks of Christ yielding up the ghost with a cry that was heard even unto hell. But the fresco is naturally free from the scholastic pedantry and detailed excruciation which often mar the narrative.

[24] This similarity was first emphasized by Aubert, pp. 119–20.

[25] Compare *Legendae Duae*, Chap. IX, sec. 3. Though scenes from the life of Mary were common in the apses of other churches as in Santa Maria Maggiore in Rome and Santa Maria in Trastevere, they usually appear in churches dedicated to the Virgin, and their iconography is far more conventional.

[26] The passages here quoted or referred to are from Teodor de Wyzewa's edition of *La Légende Dorée*, Paris 1905, pp. 430 ff. For a résumé of the representation of these subjects in French church sculpture of the thirteenth century, see E. Mâle, *L'Art Religieux du XIIIme Siècle en France*, pp. 248 ff.

[27] The appearance of thirteen apostles in both Cimabue's and Duccio's versions of the subject need not be wondered at, since St. Paul, whose presence is always mentioned, may account for the additional figure.

[28] For no very good reason this has usually been taken for Cimabue's memory conception of the Pantheon.

[29] *Codex Barbarini*, XXXIV: 50. Reproduced in Venturi, V, pp. 197 and 199.

[30] Ills. Wilpert, Vol. I, Fig. 140.

[31] For a bibliography of attributions of the work in the choir and transepts see Appendix III.

[32] In speaking thus of architecture I am obviously echoing something from the late Geoffrey Scott's admirable book, *The Architecture of Humanism*. Yet this book seems to be chiefly valuable as a reaction against various less aesthetic standards of architectural criticism; and all of his "fallacies," when not misused, have humanistic values.

[33] All modern appreciation of Giotto owes a primary debt to Bernard Berenson's *Florentine Painters of the Renaissance*.

[34] The frescoes of San Pietro in Grado near Pisa are probably retarded and imitative work at least as late as 1300, and are at all events aesthetically negligible. As one might expect, considering the Apostle to whom the basilica was dedicated, and as suggested by the Grimaldi drawings already mentioned, many of the scenes from the lives of Peter and Paul appear to have been taken over directly from the decorations of the portico of Old St. Peter's in Rome.

[35] By "Byzantine" I do not imply that they were largely executed by "Greeks." Whether or not Vasari's account of Tafi learning his craft from the Greek mosaicist Apollonius and bringing him from Venice to Florence to aid him is true, some such procedure seems natural. The few documented names of the artisans who worked on the mosaics in this baptistry appear to be Italian, as does the Franciscan Brother Jacobus who set his name in the chancel with the date 1225, and whom Vasari confused with Jacopo Torriti. Vasari also mentions Gaddo Gaddi as working on the medallions of prophets and saints beneath the windows. This master has evaded plausible reconstruction; but a congruity of style may be noted between the Coronation of the Virgin on the entrance wall of the Florentine Duomo—also assigned to Gaddo Gaddi by Vasari—and several of the lower scenes in the baptistry.

[36] The most extensive survey to date of Tuscan painting of the thirteenth century is Sirén's *Tosk. Mal.*; but this could be easily superseded, and the attributions are often careless. Well considered combinations of works attributable to certain artisans of this period, such as the so-called Magdalen Master, may be found in Offner's *Italian Primitives at Yale University*, Yale University Press, 1927.

[37] For the latest article on *dugento* Madonnas see Weigelt, *Art Studies*, Cambridge, 1928, pp. 195 *ff*.

[38] This has recently been removed from its obscure position and cleaned, and is now above one of the side altars. The new photograph and details of it, recently taken by a photographer in Orvieto, have unfortunately not been obtained by the writer for publication. Its attribution is based upon comparisons with the Madonna in the Servi in Siena, which, according to a seventeenth century report, was signed by a Coppus de Florentia with the date 1261. See Vasari, ed. Milanesi, Vol. I, p. 260, also Bacci, *Documenti Toscani*, Vol. I, pp. 1–35. The faces of the Mother and Child in the Siena altar-piece have been completely coated with Ducciesque repaint, and no longer afford comparison. Since the Servi was founded in 1265 and completed about three years later, the altar-piece in question perhaps antedates the Trinità Madonna by only a few years. Furthermore, as Van Marle has stated (Vol. I, p. 277), there is no good reason to think of Coppo as Cimabue's chief master.

[39] One must, however, discount the crown added to the Orvieto Madonna, which appears to weigh down the Virgin's head and detracts from the balance of the composition.

[40] The two upper angels in Fig. 35D are worn by cleaning and prettified by retouching.

[41] They represent three prophets of Christ, and David, his ancient progenitor. Mr. Berenson (*Art in America*, 1920) has aptly emphasized the architectural effect of this panel by comparing it with a Romanesque façade.

[42] For further consideration of the Rucellai panel and of other Madonnas variously attributed to Cimabue and his school see Appendix IV.

[43] It may be added that the small medallions of saints and angels on the frame of the Louvre painting show nothing peculiar to Cimabue's style.

[44] An exhaustive consideration of these crosses with iconographical charts is found in Sandburg-Vavalà.

[45] According to the tradition this cross was broken by falling to the floor, and it has since disappeared. But the following well known inscription was reported by Wadding and others:

> Frater Elias fieri fecit
> Jesu Christi Pie
> Miserere precantis Helie
> Giunta Pisanus me pinxit. A.D. 1236
> Ind. 9.

[46] Among the most notable and least known exceptions are the crucifix over the high altar of the San Francesco in Bologna and the two or three other crosses in the same stylistic group. But these works seem to have derived chiefly from Giunta and the Master of St. Francis and do not antedate the early work of Cimabue. See Sandburg-Vavalà, pp. 844 *ff*.

[47] For a bibliographical consideration of this and other crosses variously attributed to Cimabue and his school see Appendix III and IV.

[48] The Virgin and St. John in the wings of the Santa Croce cross show much the same incapacity to bring the Cimabue pattern to life that has already been noted in the Louvre Madonna. In fact, except for the remarkable head of the Christ, the present writer would probably have preferred to call this crucifix a *bottega* piece.

[49] See Appendix I.

[50] This commonly accepted point has been most recently considered by the present writer, "The Roman School at Assisi," *The Art Bulletin*, September 1930.

[51] The exodus of artisans following the western capture of Constantinople in 1201 is usually held responsible for this condition; though among extant works, those which were certainly executed by foreign artisans are comparatively few.

[52] Pure Byzantine painting of this second golden age is of course rare and difficult of access. Among the remaining Constantinopolitan icons of this period, "Our Lady of Vladimir," now in the Historical Museum of Moscow, is perhaps the finest and most profoundly appealing, though in its present condition little more than the faces of Mother and Child seem to be original. But the eastern technique is preserved in many later panels with or without Greek inscriptions, and the distinctions between it and the common types of Italo-Byzantine technique are usually quite unmistakable. The Madonna in the Otto Kahn collection is, as Mr. Berenson has noted, an excellent example of purely eastern tradition, no matter where or by whom it was painted. Interesting comparisons may be made between Cimabue's work and the frescoes in certain twelfth century Macedonian churches. (For illustrations see Muratoff, *La Peinture Byzantine*, Paris, 1928.)

[53] The possibility of a direct influence of the far East upon Cimabue or upon the most characteristically "Sienese" among the *trecento* painters has usually been evaded or denied; yet it is by no means impossible considering the extensive intercommunications between East and West exerted by traders and missionaries at that time (see especially *The Dawn of Modern Geography*, Vol. III, by C. Raymond Brazely). Moreover, paintings on silk or paper, if transported into Italy, would have been perishable objects and need not have survived to our day. But for lack of evidence this point is not stressed.

[54] See Appendix II.

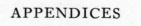

APPENDICES

# LIST OF ABBREVIATIONS

The following is merely a list of works referred to sufficiently often to make abbreviation convenient.

AUBERT. *Die malerische Dekoration der San Francesco Kirche in Assisi; ein Beitrag zur Lösung der Cimabue Frage*, by Andreas Aubert, Leipzig, 1907.

C. & C. *A History of Painting in Italy*, by J. A. Crowe and G. B. Cavalcaselle, edited with notes by Langton Douglas, London, 1903.

FREY, COD. MAGL. *Il codice Magliabechiano*, ed. Karl Frey, Berlin 1892.

FREY VASARI. *Vasari vite*, Parte I, Band I, ed. Karl Frey, München, 1911.

KLEINSCHMIDT. *Die Basilika San Francesco in Assisi*, by Beda Kleinschmidt, Berlin, 1915.

SANDBURG-VAVALÀ. *La croce dipinta italiana*, etc., by E. Sandburg-Vavalà, Verona, 1929.

SIRÉN. *Toskanische Maler im XIII. Jahrhundert*, by Oswald Sirén, Berlin, 1922.

STRZYGOWSKI. *Cimabue und Rom*, by Josef Strzygowski, Wien, 1888.

SUPINO. *La basilica di San Francesco d'Assisi*, by I. B. Supino, Bologna, 1924.

THODE. *Franz von Assisi*, by Henry Thode, Berlin, 1885. The references here included apply to the 1904 edition.

TOESCA. *Storia dell'arte italiana*, Vol. I, *Il Medioevo*, by Pietro Toesca, Torino, 1929.

VAN MARLE. *The Development of the Italian Schools of Painting*, by Raymond Van Marle, The Hague, 1923–

VASARI. See FREY VASARI.

VENTURI. *Storia dell'arte italiana*, by Adolfo Venturi, Milano, 1901–1914.

WILPERT. *Die römischen Mosaiken und Malereien*, etc., by Joseph Wilpert, Freiburg, 1907.

ZIMMERMANN. *Giotto und die Kunst Italiens im Mittelalter*, by M. G. Zimmermann, Leipzig, 1899.

# APPENDIX I

THE earliest documentary mention of Cimabue is published in Strzygowski's *Cimabue und Rom*, pp. 158–60. This document, discovered in the archives of Santa Maria Maggiore in Rome and dated June 8, 1272, concerns a nunnery of the Order of St. Damian, which was to be placed under the protectorship of Cardinal Ottoboni Fieschi, and includes among its witnesses a "Cimabove pictore de Florentia." Among the six other witnesses five are church dignitaries, and what the inclusion of a mere painter of Florence in this august gathering may signify, if anything, is impossible to tell.

His participation in the apse mosaic of the Pisan Duomo is first mentioned in a document dated September 2, 1301 (1302 Pisan time), in which he appears as master workman on the mosaic and as the recipient of four days' pay at the rate of ten soldi daily for himself and his aid. From this date records of his payment on equal terms appear weekly until January 20, 1302. At this point a brief break occurs until the important document of February 19, 1302, which specifies the St. John as his creation. The most complete publication of these documents is found in *I musaici del duomo di Pisa e i loro autori* by Giorgio Trenta, Florence, 1896, pp. 80–8. See also *Notizie di artisti tratte dai documenti pisani* by L. Tanfani Centofanti, Pisa, 1897, pp. 114–18.

Two other documents published in L. Tanfani Centofanti, *op. cit.*, pp. 119–21, show that simultaneously with his work on the apse mosaic he was commissioned along with a certain Nuchulus to paint a Virgin in Majesty and a Crucifix for the hospital church of Santa Chiara in Pisa. The first of these is dated November 1, 1301 (1302 Pisan time), and specifies the subjects to be represented and the materials to be used. The second, dated four days later, is a receipt of part payment. What

has become of this altar-piece, if it was completed, is unknown. These two documents are of especial interest since our painter is here cited as "Magister Cenni dictus Cimabue pictor condam Pepi de Florentia." Thus his real name was Cenni di Pepi or Pepe—not the Giovanni Cimabue of tradition. We find also that he was at that time "de populo Sancti Ambrosii" of Florence.

Final mention of him occurs in a Florentine document dated July 4, 1302, which shows him to have been a member of the society of the Piovuti. See Supino, *Arte Pisana*, Florence, 1904, p. 251, or Frey Vasari, I, p. 443.

# APPENDIX II

AN exhaustive study of the Cimabue legend down to the nineteenth century is found in Ernst Benkard's *Das litera-rische Porträt des Giovanni Cimabue*, München, 1917, which is indebted to the epigraphical researches of Karl Frey. The following brief critical synopsis is founded chiefly on their works.

The first literary mention of Cimabue is to be found in the often quoted passage from Dante's *Purgatorio*, Canto XI, 92–7:

> O vanagloria dell'umane posse,
> Com'poco verde in su la cima dura,
> Se non è giunta dall'etati grosse!
> Credette Cimabue nella pintura
> Tener lo campo; ed ora ha Giotto il grido,
> Sì che la fama di colui oscura.

There is no reason to think this other than a record of fact turned by the poet into the theme of *sic transit gloria mundi*.

Whether or not the *trecento* commentators on these verses—Jacopo della Lana, "Ottimo," Petrus Allegherius, and Benvenuto da Imola—merely elaborated slightly upon Dante's lines without other substantiation is unknown; but they agree as to the great fame of Cimabue in his day. By far the most interesting of these commentaries, and the only one which adds substantially to the words of Dante, is that of "Ottimo" (*L'Ottimo Commento della Divina Commedia*, ed. Alessandro Torri, Pisa, 1828, Vol. II, p. 188), who wrote probably about 1333–1334 (for dating see Frey Vasari, pp. 399–400, n. 16) as follows:

> Fu Cimabue nella città di Firenze pintore nel tempo dello Autore, molto nobile, de' più che uomo sapesse; e con questo fu sì arrogante, e sì sdegnoso, che se per alcuno gli fosse a sua opera posto alcuno difetto, o egli da sè l'avesse veduto (chè come accade alcuna volta, l'artifice pecca per difetto della materia in ch'adopera, o per mancamento che è nello strumento, con che lavora) immantanente quella cosa disertava, fosse cara quanto si volesse.

Incidental mention of Cimabue is made in *novella* 136 of Franco Sacchetti, where he is simply suggested, along with Stefano, Bernardo Daddi and Buffalmacco, as a possible second to Giotto in painting.

Fifteenth century sources give no verifiable additions to our knowledge of the painter. Philippo Villani's *De famosis civibus*, dating from the first years of the century, mentions Cimabue as the first reviver of a more natural style of painting. Here also his surname appears erroneously for the first time as Joannes or Giovanni. (For text see Karl Frey, *Il libro di Antonio Billi*, etc., Berlin, 1892, p. 73.)

An anonymous commentator on Dante, probably of the fifteenth century (for dating see Frey, "Studien zu Giotto," *Jahrbuch d. kgl. preuss. Kunstsmlgn.*, Vol. VI, p. 111) reechoes the tradition of Cimabue's fame, says that many of his works are to be found in Florence and elsewhere, and specifies *uno palio* in Santa Maria Nuova. (*Commento alla Divina Comedia d'Anonimo Fiorentino del secolo* XIV, ed. Pietro Fanfani, Bologna, 1866, Vol. II, p. 187.)

Lorenzo Ghiberti in his *Commentarii*, dating about 1452-1455, mentions Cimabue only incidentally and in relation with the boy Giotto. But he is the first discoverable source of the well known story, repeated by Vasari, to the effect that the elder painter came upon the younger as a shepherd boy drawing a sheep on a rock, and offered to take him as a pupil. (For text see Karl Frey's edition of Vasari's *Vita di Lorenzo Ghiberti Scultore Fiorentino*, Berlin, 1886, p. 33.)

Cristoforo Landino in his *Epilogo*, 1480, sums up the usual vague contemporary conception writing thus:

Fu adunque il primo Giouannj Fiorentino cognominato Cimabue, che ritrouo e lineamentj naturali et la uera proportione, laquale i Grecj chiamono simetria, et le fiure, ne superiorj pittorj morte, le fece uiue et di uarii gesj et gran fama lasciò di se. Ma molto maggiore la lasciaua, sinon hauesse hauto si nobile successore, quale fu Giotto Fiorentino, coetaneo di Dante. (Frey, *Cod. Magl.*, p. 119.)

The sixteenth century accounts, however, have somewhat more to offer. Albertini in his *Memoriale*, 1510, mentions *una tavola grandissima* in Santa Maria Novella—doubtless the Rucellai Madonna—as the work

of Cimabue, and attributes to him a large wooden crucifix in Santa Croce—probably the one now in the *Museo dell'opera* of this church and still usually accepted as his work. (For text see *Memoriale di molte statue e pitture della città di Firenze*, by Francesco Albertini, republished by Mussini and Piaggio, Florence, 1862, p. 15.)

Antonio Billi was the first to make out a list of attributions to Cimabue. His work according to Frey (*Cod. Magl.*, p. lix) falls between 1516 and 1525. But the original is lost, and only two later and interpolated versions remain—the *Codex Strozzianus* and the *Codex Petrei*. (For text see Karl Frey, *Il libro di Antonio Billi*, etc., Berlin, 1892, pp. 4 and 5.) The original contributions of Billi are, at least for the present writer, impossible to ascertain. (For analyses see Frey, *Billi, ed cit.*, pp. iii–xxi; also Frey, *Cod. Magl.*, pp. lvi–lx.) Yet except for probable later additions in the *Codex Petrei*—such as a more definite dating of Cimabue's life, the attributions of the Madonnas in Santa Trinità in Florence and San Francesco in Pisa, and the incidents relating to the Rucellai Madonna—all of which may well have been taken over from Vasari, the Billi versions agree somewhat in substance and exactly in attributions with the *Codex Magliabechianus*, and it seems probable that the writer of this latter codex drew directly from the original work of Billi. The attributions mentioned by both are as follows: a Madonna in the Rucellai Chapel of Santa Maria Novella in Florence, probably to be identified with the extant "Rucellai Madonna" (for a consideration of this work see Appendix IV); a St. Francis panel in San Francesco in Pisa, probably the one now in the *Museo Civico* of that city and certainly earlier than Cimabue; certain *historie* in the cloister of Santo Spirito in Florence, which, whether or not they were by our painter, have disappeared; work in the Pieve at Empoli, which has also disappeared; and, most important, decorations in San Francesco in Assisi. The anonymous writer of the *Cod. Magl.* also repeats Landino's estimate of Cimabue's art almost word for word—*"ritrovo i lineamenti naturali e la vera proportione, da Greci chiamata simetria"*; and he mentions Giotto as Cimabue's disciple and Gaddo Gaddi as his friend. (For the text see Frey,

*Cod. Magl.*, p. 49; and for the 1537–1542 dating see W. Kallab, *Vasari-studien*, Wien-Leipzig, 1908, p. 181.)

Giovanni Battista Gelli in his *Vite d'artisti* (for text see *Archivio storico italiano*, serie V, Vol. XVII, pp. 38–9, ed. Mancini; and for 1549–1555 dating see Kallab, *op. cit.*, p. 182) mentions Cimabue as famous about 1280, as a strict adherent to the "Greek" style, and as the first indigenous Italian painter. He repeats the *Cod. Magl.* list of Cimabue's works (excepting that in the Pieve at Empoli) and adds the Santa Cecilia altarpiece also mentioned in Vasari's 1550 edition, which is approximately contemporary with Gelli's writing.

But Vasari is the great repository for the Cimabue tradition; and the second edition of his *Vita di Cimabue pittore fiorentino*, which appeared in 1564, four years earlier than the completed edition (see Kallab, *op. cit.*, p. 295) not only comprehends the aforementioned sources (Ghiberti's story being naturally relegated to the life of Giotto) but adds much new matter drawn from sources lost to us, from word-of-mouth tradition, or from his own invention. Nor are there any noteworthy additions to the legend after him, excepting Filippo Baldinucci's quite improbable seventeenth century dictum that our painter belonged to the noble Florentine family of the Gualtieri. (For text see *Notizie de' professori del disegno*, ed. Piacenza, Torino, 1768, Vol. I, pp. 16–21.)

None of Vasari's additions, excepting the attribution of the Santa Trinità Madonna, are based on demonstrable fact, and most of them are either improbable or palpably wrong, as his many commentators have shown. And since this field has been adequately covered, all but the briefest summary is here omitted. (For both of Vasari's texts and the most complete commentary see Frey Vasari I, pp. 389–462.) Whether or not his 1240 dating for Cimabue's birth is a mere guess is unknown, but since it agrees well enough with known facts and probabilities, it is generally accepted as approximately correct. The *"nobil famiglia in que tempi de Cimabui"* is of course a myth probably suggested by Ottimo's comment, *"molto nobile, de' più che uomo sapesse."* That the boy Cimabue neglected his grammar for drawing and for watching certain Greek

artists at their tasks can of course not be disproved, but has usually been repudiated on the grounds that the present church of Santa Maria Novella was not begun until 1279. Wood-Brown, however, (*Repret. für Kunstwissenschaft*, 1901, pp. 127 *ff.*) believes that the transept was begun soon after a papal bull of 1246, and sees no reason why the present Gondi chapel should not have been standing during Cimabue's boyhood. The difficult problem of the Rucellai Madonna is summarized elsewhere. Charles I of Anjou, however, could scarcely have seen it, since according to Villani he visited Florence in 1267. Cimabue's assistance to Arnolfo in his design of Santa Maria del Fiore may also seem improbable, though not as impossible as Frey (Frey Vasari, p. 461) implies. The year 1300 is as good an approximation of his death as one could expect; but that he was buried in Santa Maria del Fiore beneath the doggerel epitaph, which could not have antedated Dante's lines, is almost certainly a late fiction. Neither is there any substantiation for the legend that the figure in the Spanish Chapel, still pointed out as representing Cimabue, is in any way authentic, even if at best it is an ideal portrait of the painter some sixty years after his death.

In his first edition Vasari repeats the attributions of the anonymous writer in the *Cod. Magl.* adding the Santa Cecilia altar-piece, which has given the name of the Santa Cecilia Master to the painter of it and of other works in the same style, and also a Madonna in Santa Croce, which is probably to be identified as the badly repainted Ducciesque panel in the National Gallery in London.

In his second edition Vasari adds to these attributions the following non-extant works: two frescoes in the Spedale del Porcellana in Florence, a panel presenting St. Agnes with scenes from her life in S. Paolo in ripa d'Arno at Pisa, and a small Crucifixion in tempera in S. Francesco at Pisa. He also adds the Santa Trinità Madonna, the Madonna of San Francesco in Pisa, now in the Louvre, the Santa Croce Crucifix (already noted by Albertini), and a St. Francis altar-piece in Santa Croce, which is probably the one still to be seen in the St. Francis Chapel of this

church, and which is a much earlier work (for illustration see Sirén, Figs. 24 and 25).

In this edition Vasari writes at greater length on Cimabue's work at Assisi, where, according to his own word, he returned in 1563. He here ascribes the "Master of St. Francis" scenes and part of the vault decorations in the lower church to Cimabue aided by Greek masters, and to his unaided hand all the decorations of the upper church excepting the St. Francis series, which he also began before being called away to Florence.

Yet in spite of much that may seem preposterous in this "Life of Cimabue," it apparently sums up almost all that could then be known without documentary information. And although the race of artists was not, as Vasari thought, completely extinguished in Italy before the advent of Cimabue, yet his supreme importance, and the derivation of his work from "Greek" artists, whom he excelled, seems borne out by fact.

# APPENDIX III

THE following is a bibliographical synopsis on works accepted in the text as authentic Cimabues, and considered in what is here held to be the approximate order of their execution.

The Crucifix in San Domenico in Arezzo was attributed to Margaritone by Douglas, C. and C., Vol. I, p. 165, n. 2. Venturi, Vol. V, p. 27, mentions it along with several other crosses, saying of them "*sembrano . . . annunciare la grande arte di Cimabue*." Sirén, pp. 254 *ff.*, assigns it to Coppo di Marcovaldo on the strength of a not very convincing comparison of the Virgin and St. John in the wings of the cross with Coppo's Orvieto Madonna. Toesca, p. 1011, attributed it directly to Cimabue, and is supported by Sandburg-Vavalà, p. 776, and Berenson in his forthcoming lists.

The Santa Trinità Madonna, now in the Uffizi, has commonly been accepted as authentic, except by such completely negative critics of Cimabue as Wickhoff, Richter and Douglas. It has been considered a comparatively early work by all except Sirén who places it late (p. 286) on account of stylistic comparisons with the St. John at Pisa. As noted in the text, however, the present writer prefers to consider these resemblances as signs of the persistent unity of Cimabue's style.

The Madonna enthroned and St. Francis in the lower church in Assisi has also been commonly attributed to Cimabue. The upper part, especially the Virgin and Child, has of course been badly renovated, but the angels retain something of their Cimabue quality. Perhaps a St. Antony of Padua, now covered by an ornamental strip, once balanced the St. Francis on the other side.

In the upper church in Assisi, the parts of the decoration attributable to Cimabue have been variously distributed. Vasari, as already noted, assigned all except the St. Francis series to Cimabue. Since most of the

writers from C. and C. on ascribe none of the work in the nave to the master, this will be taken for granted unless otherwise indicated. C. and C., Vol. II, p. 3: Giunta Pisano in right transept, Cimabue in left. (Giunta was probably included merely because of the wooden Crucifix he is known to have painted for this church; and the assumption that he was responsible for some of the fresco work had already been made by such historians of this basilica as Padre Angeli, *Collis Paradisi*, etc., Montefalisco, 1704, lib. II, p. 32, and Carlo Fea, *Descrizione ragionata della sacrosanta patriarcal basilica*, etc., Roma, 1820, p. 14.) Thode, p. 235: all to Cimabue. Strzygowski, pp. 173–4: to Cimabue himself the choirvault, the Apostle scenes and the left Crucifixion; he includes the apocalyptic and Virgin scenes with the right Crucifixion as weaker and more schematic work done largely by assistants. Zimmermann, pp. 209–210: choir and left transept to Cimabue; right transept to an earlier hand but not Giunta's; "Angels before Abraham" in nave to Cimabue (see plan, p. 270). Roger Fry, "Giotto," *Monthly Review*, 1901, pp. 146–8: all to Cimabue without conviction and with faint praise. Venturi, Vol. V, pp. 216–17: all to Cimabue probably assisted by an aid whose work appears especially in the upper right transept. Aubert, pp. 28, 34–8, 117 *ff.*: upper right transept pre-Cimabue; remainder to Cimabue, the right Crucifixion being an earlier work. Frey Vasari, I, pp. 451 *ff.*: Cimabue with assistants. Sirén, pp. 321 *ff.*: choir and left transept to Cimabue and assistant; most of right transept not under Cimabue's direction. Van Marle, Vol. I, pp. 471 *ff.*: left Crucifixion, apocalyptic and lower Virgin scenes and choir-vault to Cimabue; remainder to several assistants, excepting probably the earlier Crucifixion in the right transept. Supino, p. 96: Cimabue and assistants. Kleinschmidt, Vol. II, pp. 56 *ff.*: Cimabue and assistants except for the older work in the upper right transept. Toesca, pp. 1003 *ff.*: all to Cimabue. Toesca (*Florentine Painting of the Trecento*, Pegasus Press, 1929, p. 11) assigns even the following sections in the nave to Cimabue: the "Building of the Ark," the "Sacrifice of Isaac," the "Nativity," and the "Kiss of Judas."

It will be noted that the writers who have not accepted all the painting

of the choir and transepts as Cimabue's have usually distinguished most of the work in the right transept from the rest, some of them seeing the total difference of style in the decoration of the upper part of this transept, and the inferiority of much of the work in the lower. It is inconceivable, however, to the present writer that any of the frescoes in the nave should be attributed to Cimabue, though his influence in certain sections is obvious.

The Santa Croce Crucifix, now in the *Museo dell'opera* of that church, still offers a difficult problem on account of its comparative lack of vigor. But the reasons for considering it, at least in part, a work of Cimabue have been considered in the text. C. and C., Vol. I, pp. 183–4; Aubert, p. 108; Suida, *Jahrb. der königl. preuss. Kunstsammlungen*, 1905, p. 38; Sirén, p. 296; Toesca, p. 1010; and Sandburg-Vavalà, pp. 767 *ff.* assign it to Cimabue himself; Zimmermann, p. 222, either to Cimabue or to one who approximated his style; and Venturi, Vol. V, p. 27; Frey Vasari, I, p. 435; Van Marle, Vol. I, p. 475, to a follower of the master.

The St. John in the apse mosaic of the Pisan Duomo has of course been universally accepted; though according to Richter (*Lectures in the National Gallery*, London, 1898) "but for the evidence of the above mentioned document, no one would now dream of ascribing the work in its present condition (especially the St. John, a most uninteresting figure) to *any* great master." The work, however, is not highly restored, and is in every way characteristic of Cimabue.

## APPENDIX IV

THE following works are not attributed here to the master's hand, but show greater or less proximity to his style. If the writer has excluded certain works assigned to Cimabue by maturer critics than himself, it is merely from a desire to focus the attention upon the peculiarities of this artist's most authentic work—its typical geometry, its technique, and its emotional and psychic content. The results are based upon a three years' study of these works —especially the ruins in Assisi.

There is no attempt here to reproduce a complete bibliographical or archaeological discussion of the Rucellai Madonna, especially since the only dogmatic conclusion which the writer has reached concerning it is that Cimabue had nothing to do with its painting; and he sees little difficulty in accepting the view that the document of 1285 (see *Documenti per la storia dell'arte senese*, ed. G. Milanesi, Siena, 1854, Vol. I, p. 158), which proves that Duccio was commissioned to paint such an altar-piece for Santa Maria Novella, pertains to this painting. The lapse of twenty-five years between this date and that of the great Sienese altar-piece is ample to account for any slight differences in technique in the work of one who painted in a period of such strenuous development; and the following hypothesis seems to me most plausible: that Duccio, working in Florence in 1285, was superficially influenced by such a work as the Santa Trinità Madonna—probably executed no later than 1280. These influences, indeed, amounted to little more than the arrangement of several angels around the throne, instead of the usual two in the upper corners, to the tiring-pins whereby their haloes are attached to their hair, and to certain loose analogies in feature and modelling between the faces of the Virgins. Yet instead of the angular eyebrows and serrated headdress of Cimabue's Virgin, the head and

features of the Rucellai Madonna are composed of fluid curves producing the effect of languor instead of psychic awareness. In fact, the peculiar and rarified content of the face of the Rucellai Virgin, for all its harder surface, is similar to that of Duccio's later Madonnas; while the angels and the drapery of the Virgin are exquisitely Duccian. Following this hypothesis, it is also interesting to note that only the two topmost angels—which would probably have been the first painted—retain in their features a slight Cimabuean imprint. In fine, if one attributes this panel to an unknown painter, one must presuppose an artist who was a consummate master of Duccio's style and spirit and who chose a more archaic rendering of them. To the popularity of this painting the more or less debased imitations of the Virgin's face bear witness. The Louvre "Cimabue" has already been mentioned in this connection in the text, and much the same may be said of the faces of the Mosciano and Gualino Madonnas—the latter having been ascribed to Cimabue by L. Venturi (*La Collezione Gualino*, Turino-Roma, 1926, tavola I). For a convincing archaeological substantiation of the Rucellai Madonna see J. Wood-Brown, "Cimabue and Duccio at Santa Maria Novella," *Repert. für Kunstwissenschaft*, 1901, pp. 127 *ff.* A bibliography of attributions follows:

To Cimabue:

C. and C., pp. 181–2; Strzygowski, pp. 55 *ff.*; Zimmermann, pp. 217 *ff.*; Roger Fry, "Giotto," *Monthly Review*, 1901, p. 147, and A. Chiapelli, "Per la Madonna Rucellai," *L'Arte*, 1907, pp. 55–9.

To Duccio:

Fineschi, *Antico Cimiterio di S. M. Novella*, 1790, p. 118, and quoted by J. Wood-Brown, *Repert. für Kunstwiss.*, 1901, pp. 127 *ff.*; Wickhoff, *Mitt. d. Inst. f. österr. Geschichtsforschung*, 1889, pp. 244 *ff.*; Richter, *Lectures in the National Gallery*, London, 1898, pp. 6 *ff.*; J. Wood-Brown, *loc. cit.*; Venturi, Vol. V, p. 554; Aubert, pp. 139 *ff.*; Weigelt, *Duccio*, pp. 123–39; Mather, *A History of Italian Painting*, pp. 63–4; Van Marle, Vol. II, pp. 8 *ff.*

To a third artist:

Suida, *Jahrb. der königl. preuss. Kunstsammlungen*, 1905, pp. 28 *ff.*, finally recanting in favor of Duccio, *Monatshefte für Kunstwiss.*, 1909, pp. 64 *ff.*; F. M. Perkins, *Rassegna d'Arte*, p. 36, n. 3; Toesca, p. 1011; Berenson, *The International Studio*, October 1930.

Toesca, however, thinks of this artist as a direct Cimabue follower, whereas Thode (*Repert. für Kunstwiss.*, 1890, pp. 34 *ff.*) and Sirén (pp. 301–9) hold that Cimabue finished the work begun by Duccio.

The Louvre Madonna has, superficially at least, so many of the peculiarities of Cimabue's design that one must think it at least a *bottega* piece. Yet, as already mentioned, its uniform deadness, and especially the mask of the Virgin, seem to the writer sufficient reasons for excluding it from our painter's authentic works. Strzygowski (p. 192) was the first to suggest that it is a late shop work, and his opinion is supported by Aubert (p. 140); Suida (*Monatshefte für Kunstwiss.*, 1909, p. 67); and Van Marle (Vol. I, p. 474). Other writers—excepting such a negative critic as Douglas (C. & C., Vol. I, plate opp. p. 182) who assigns it to the early Sienese school—have commonly accepted the attribution, usually noting its inferiority to the Santa Trinità Madonna.

The Madonna of the Servi in Bologna attributed to Cimabue by Thode, p. 237; Strzygowski, p. 187; Zimmermann, p. 220, n. 1; Aubert, pp. 101–2; Sirén, p. 291; and Toesca, p. 1007, appears to the writer, in its present condition, to show only a Cimabuean influence in the faces and perhaps in the throne. Yet it is not inconceivably a shop piece of the master's.

Concerning the Madonna in the collection of Lord Lee, attributed to Cimabue by Sirén (*The Burlington Magazine*, 1923, XLIII, pp. 206 *ff.*) I can judge from the reproduction only. What is most evident is that excepting the softened face of the Virgin, the misunderstood hatching, and the quite non-Cimabuean head of the Child, it is a stereotyped duplicate of the central group of the Santa Trinità Virgin Enthroned—the Child having been raised slightly to unite the composition. Whether or

not the softening of the Virgin's face is merely repaint on a Cimabuean structure I am in no position to tell; yet judging from the apparent lack of high quality, from the improbability that the master would have painted such a dull replica, and especially from the *trecentesque* head of the Child, which suggests nothing of Cimabue's structure or pattern beneath the surface painting, I must tentatively consider it the work of a later and eclectic copyist.

In the tryptich published by Berenson (*Art in America*, 1920, pp. 251 *ff*.) the heads, especially that of Christ, have an obvious Cimabuean stamp. But the smoothly flowing draperies, and the gracility of the hands (unparalleled in Cimabue's male figures) serve to augment the total effect of a not altogether pleasant combination of Cimabuesque grimness with over-refined elegance. And for the writer it is a school piece of high technical quality. As Toesca has pointed out (p. 1041) it was originally a polyptych with an additional figure at either end (see Artaud de Montor, *Peintres primitifs*, Paris, 1843, pp. 30 *ff*.). The article has since been republished with de Montor's illustrations of the end panels in Berenson's *Studies in Mediaeval Painting*, The Yale University Press, 1930.

In the Crucifix of Santa Chiara in Assisi which Thode (p. 236) assigned to Cimabue, the body of the Christ is heavily coated with baroque repainting. But from the original parts still visible Aubert (pp. 133 *ff*.) assigned it along with a Madonna in this church (also given to Cimabue by Thode, p. 237) to the master of the large panel representing St. Claire with scenes from her life. In fact there are no extant crosses, excepting the two considered in the text, that can be closely associated with Cimabue, and among those assigned to his *Richtung* by Sirén (pp. 324 *ff*.) only that in Santa Maria del Carmine in Florence shows any definite stylistic influence of the master; though the grouping and gestures of the Virgin and St. John in the unusual Hendecourt Crucifix, now in the Fogg Museum at Harvard, show analogies with their counterparts in the Crucifixion of the upper church in Assisi.

The frescoes in the St. Michael's Chapel in Santa Croce in Florence were assigned by Thode (p. 238) and Venturi (Vol. V, p. 217) to Cima-

bue. But I agree with Van Marle that Zimmermann (p. 222) made as
correct an attribution as possible when he assigned the "Quelling of the
Dragon" to one influenced by both Cimabue and Giotto, and the
"Miracle of Gargano" on the wall opposite to a later Giotto follower.

That the decorations of the portico of Old St. Peter's may have been
by Cimabue is suggested by Venturi (Vol. V, p. 195), who apparently
wished to find some traces of the master's early stay in Rome, and who
saw the iconographical analogies between certain of the Grimaldi draw-
ings and several of the sections in the right transept of the upper church
in Assisi. The impossibility of stylistic comparison from these very free
seventeenth century "copies" is of course obvious; moreover the extant
fragments from this portico are work of the Roman School (Ills. Wilpert,
Vol. I, Fig. 144).

More interesting, however, is Venturi's suggestion (Vol. V, pp. 229 ff.)
that Cimabue aided on the lower rows of the Florentine baptistry—an
hypothesis repeated with variations by Toesca (p. 1003) and already
considered in the text.

The heavily repainted Madonna in the London National Gallery at-
tributed originally by Vasari to Cimabue, was assigned probably rightly
by Richter to Duccio's school. And I am aware of no one who still retains
the old attribution excepting Sir William Orpen in his *Outline of Art*.

Since the above was written, two recent articles on the Rucellai
Madonna by Weigelt (*Art in America*, December 1929 and April 1930)
have appeared, which coincide substantially with the present writer's
opinion. Also a small book has been published by Soulier (*Cimabue,
Duccio, et les premières écoles de Toscane à propos de la Madone Gualino*,
Paris, 1929) which ascribes to Duccio not only the Rucellai Madonna,
but the Louvre, Bologna and Gualino Madonnas as well, and is chiefly
remarkable as an example of bad connoisseurship.

Fig. 1.  Assisi: Upper Church, Choir Vault. St. Matthew Evangelist. Cimabue. *Photo Brogi.*

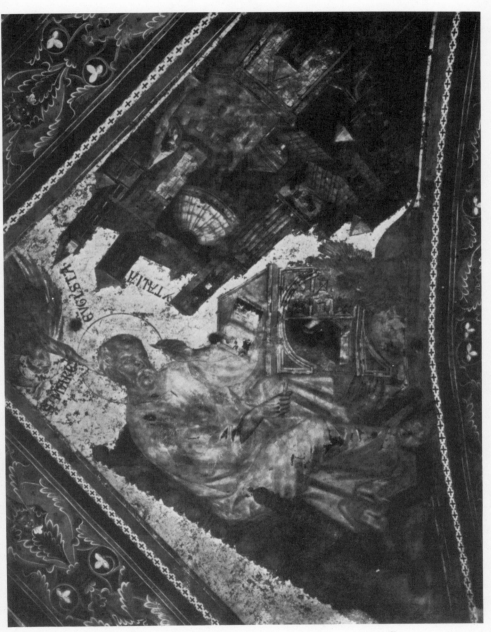

Fig. 2. Assisi: Upper Church, Choir Vault. St. Mark Evangelist. Cimabue. *Photo Brogi.*

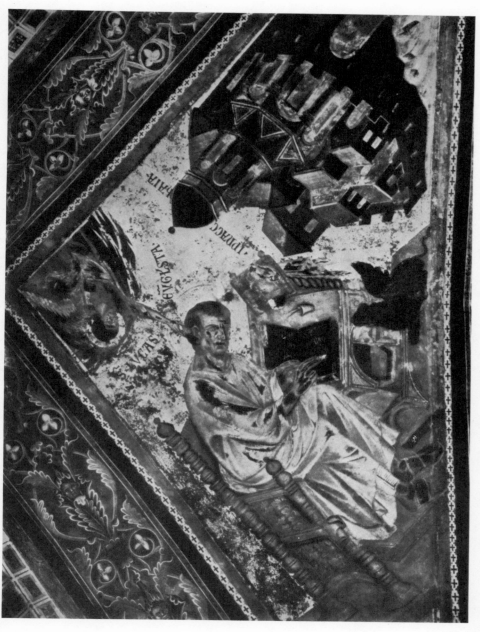

Fig. 3. Assisi: Upper Church, Choir Vault. St. Luke Evangelist. Cimabue. *Photo Brogi.*

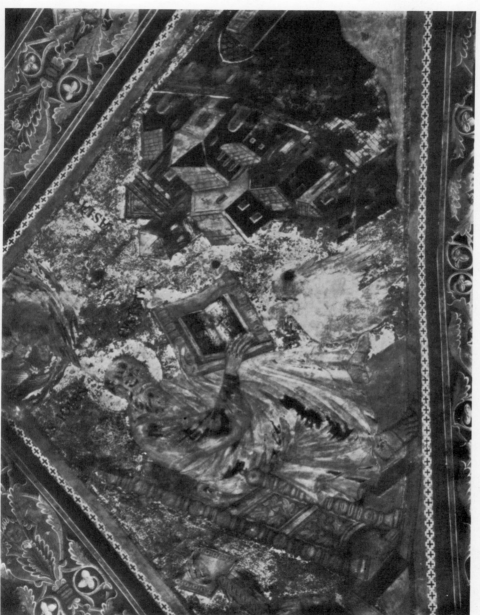

FIG. 4. Assisi: Upper Church, Choir Vault. St. John Evangelist. Cimabue. *Photo Brogi.*

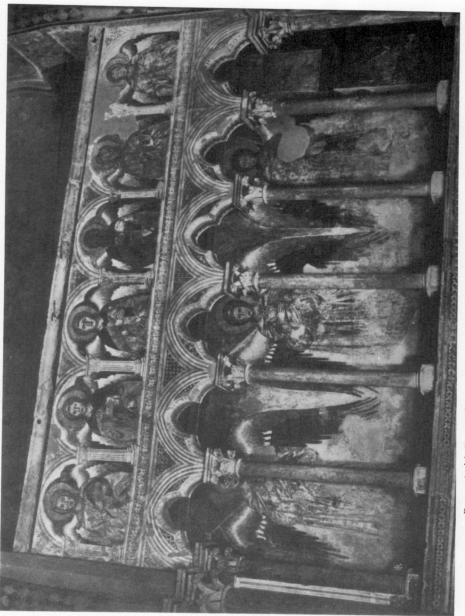

Fig. 5. Assisi: Upper Church, Left Transept. Angels. Assistant to Cimabue. *Photo Anderson.*

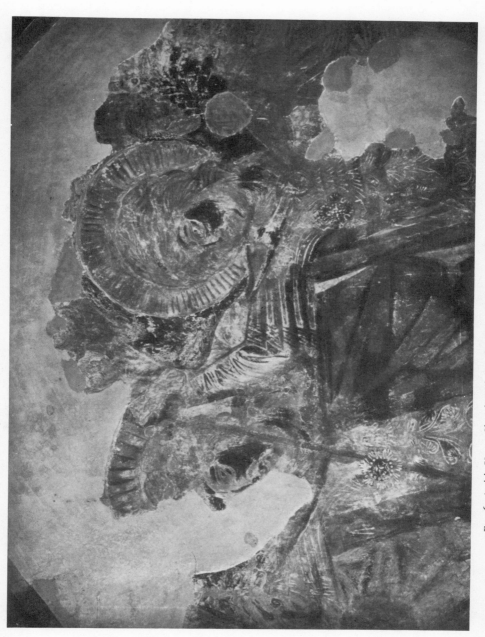

FIG. 6. Assisi: Upper Church, Left Transept. Detail from the Fall of the Serpent. Cimabue.

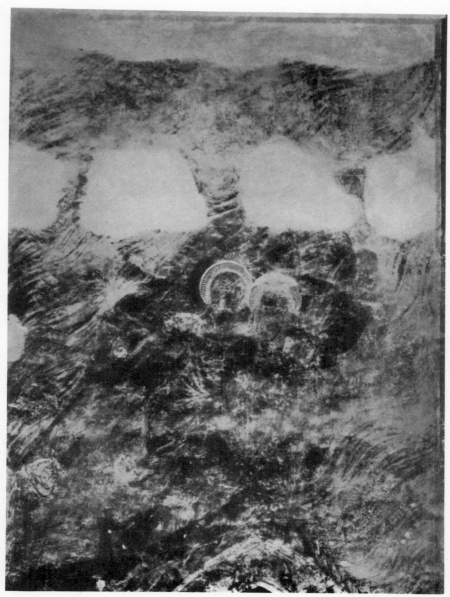

FIG. 7. Assisi: Upper Church, Left Transept. St. John on Patmos. Cimabue. *Photo Carloforti.*

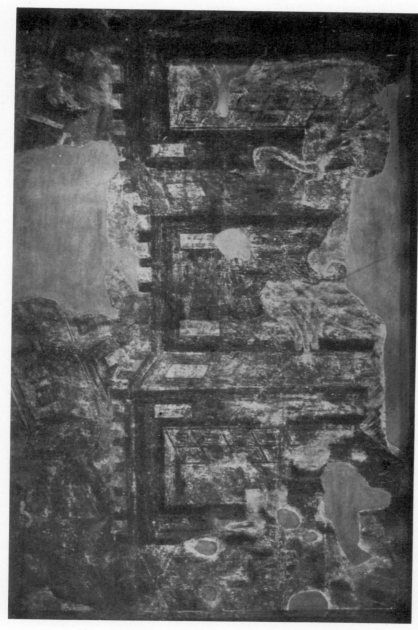

Fig. 8. Assisi: Upper Church, Left Transept. Detail from the Fall of Babylon. Cimabue. *Photo Brogi.*

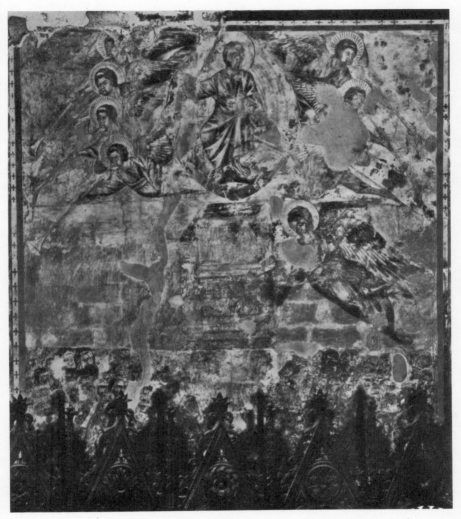

FIG. 9. Assisi: Upper Church, Left Transept. Apocalyptic Christ with Angels. Cimabue.
*Photo Anderson.*

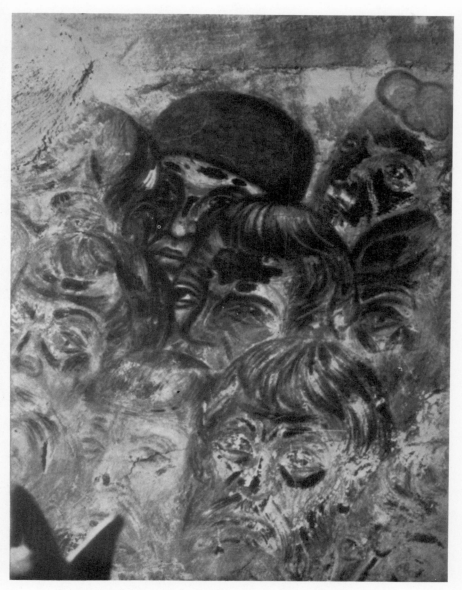

FIG. 9a. Detail from Apocalyptic Christ with Angels. Cimabue. *Photo Brogi.*

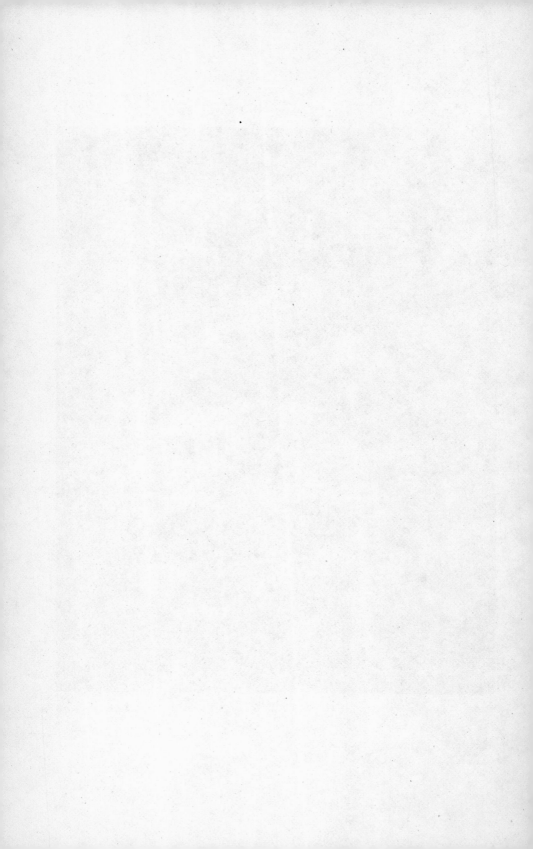

FIG. 10. Assisi: Upper Church, Left Transept. The Four Winds. Cimabue.
*Photo Anderson.*

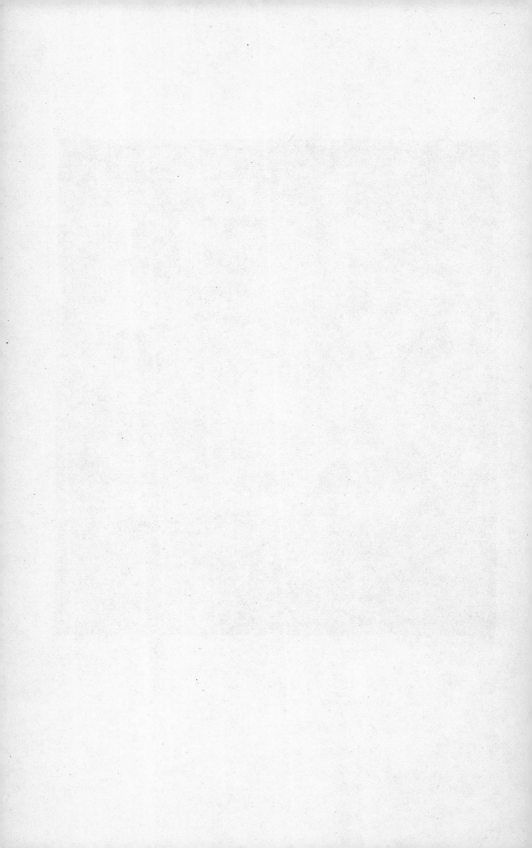

FIG. 11. Assisi: Upper Church, Left Transept. The Infant Christ on the Throne. Cimabue.
*Photo Anderson.*

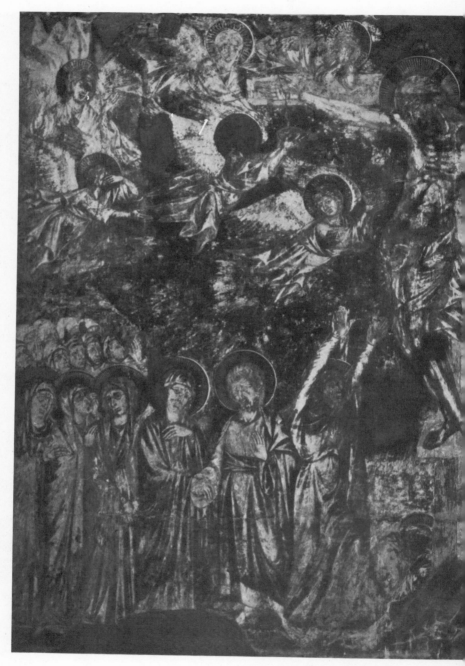

Fig. 12. Assisi: Upper Church, Left Transept.

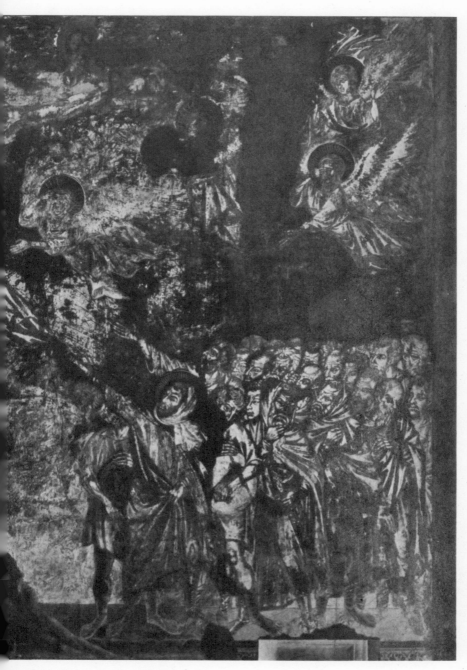

The Crucifixion. Cimabue. *Photo Anderson.*

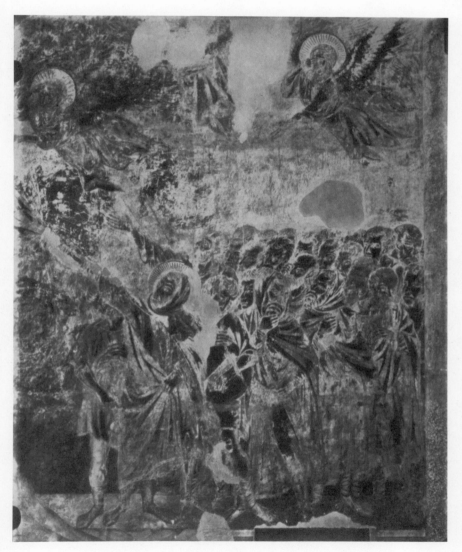

FIG. 12a. Detail from the Crucifixion. Cimabue. *Photo Anderson.*

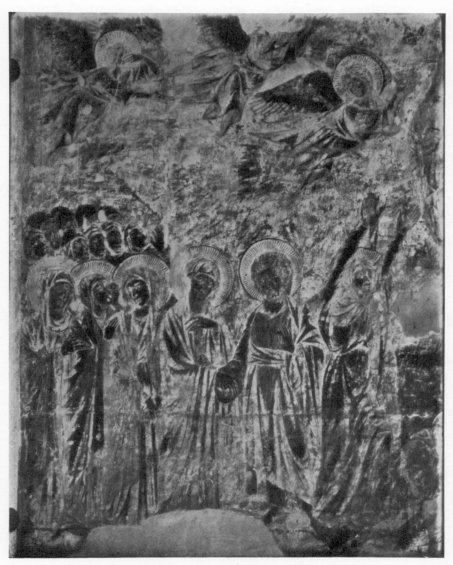

FIG. 12*b*. Detail from the Crucifixion. Cimabue. *Photo Anderson.*

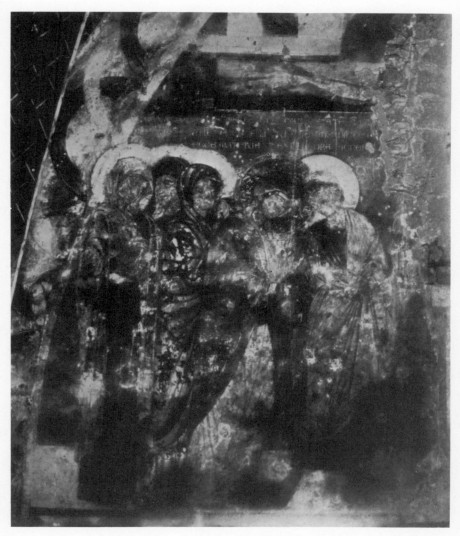

FIG. 13. Assisi: Lower Church, Nave. Extant Part of Crucifixion. Master of St. Francis.
*Photo Carloforti.*

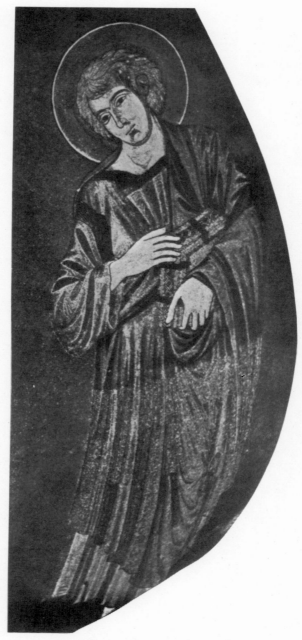

Fɪɢ. 14. Pisa : Duomo, Apse. St. John. Cimabue. *Photo Brogi.*

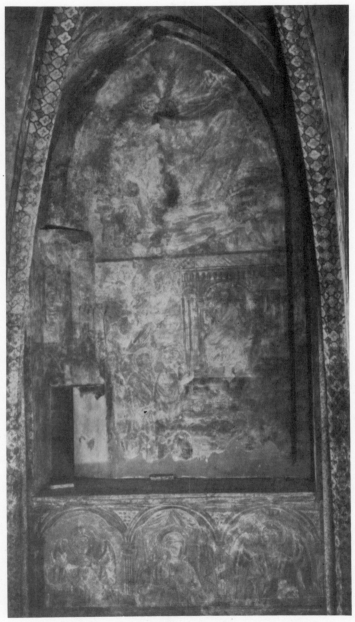

FIG. 15. Assisi : Upper Church, Apse. Annunciation to Joachim and Suitors before
High Priest, greatly renovated. *Photo Brogi.*

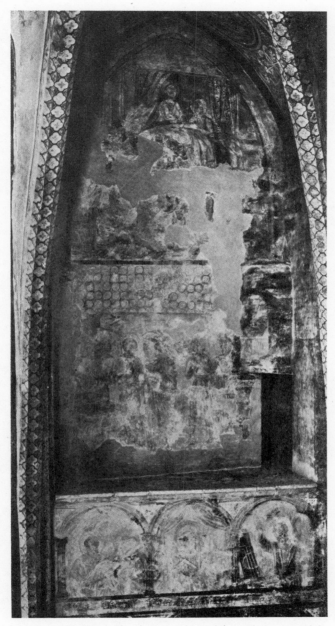

FIG. 16. Assisi: Upper Church, Apse. The Nativity and Marriage of the
Virgin, greatly renovated. *Photo Brogi.*

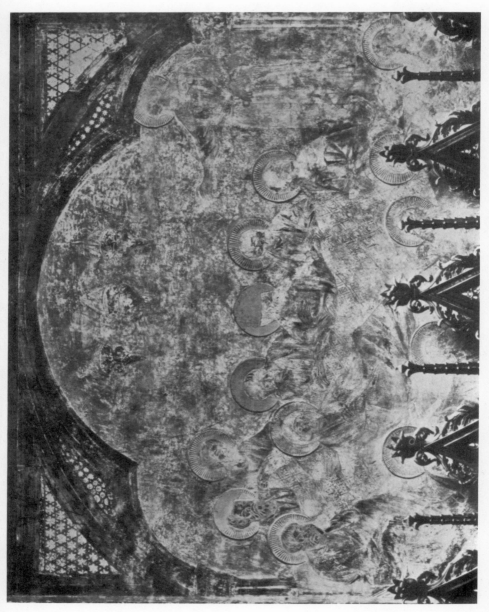

FIG. 17. Assisi: Upper Church, Apse. The Last Hour of the Virgin. Cimabue. *Photo Anderson.*

Fig. 17a. Detail from the Last Hour of the Virgin. Cimabue. *Photo Broga.*

Fig. 18. Assisi: Upper Church, Apse. The Dormition. Cimabue. *Photo Brogi.*

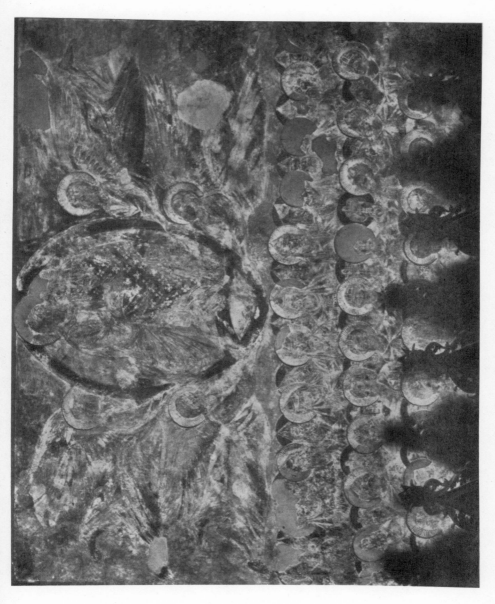

Fig. 19. Assisi: Upper Church, Apse. The Assumption. Cimabue. *Photo Anderson.*

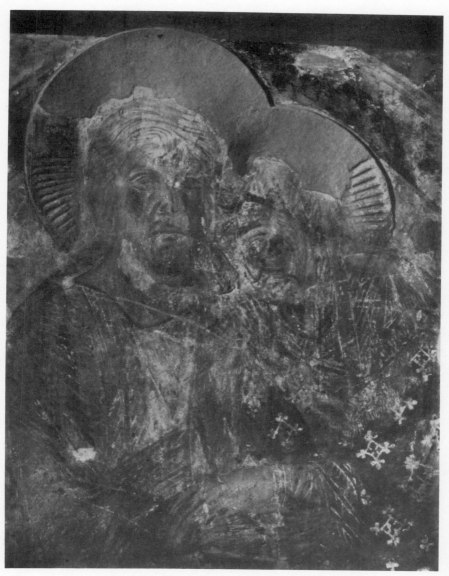

FIG. 19a. Detail from the Assumption. Cimabue. *Photo Brogi.*

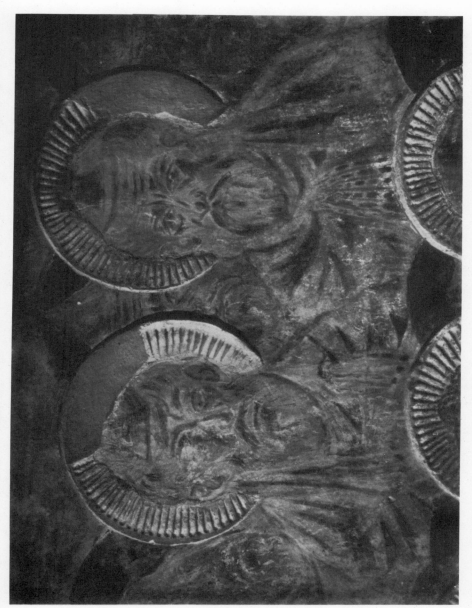

FIG. 19b. Detail from the Assumption. Cimabue. *Photo Brogi.*

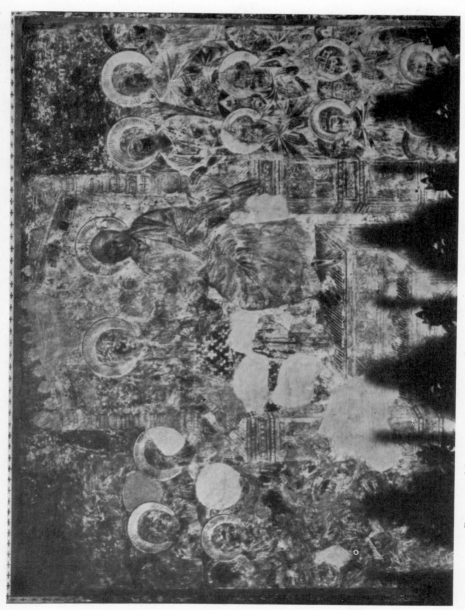

Fɪɢ. 20. Assisi: Upper Church, Apse. Christ and the Virgin Enthroned. Cimabue. *Photo Anderson.*

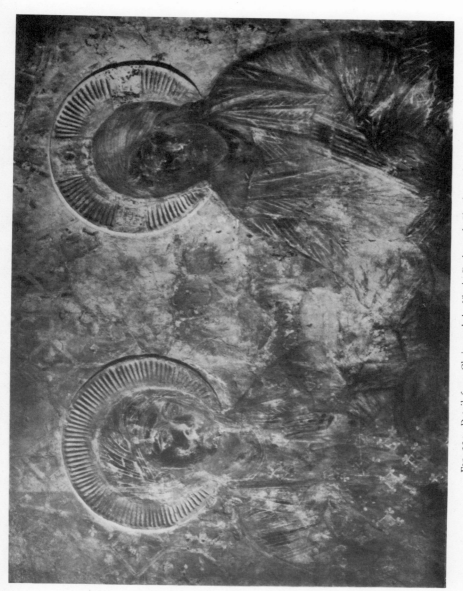

Fig. 20a. Detail from Christ and the Virgin Enthroned. Cimabue. *Photo Brogi.*

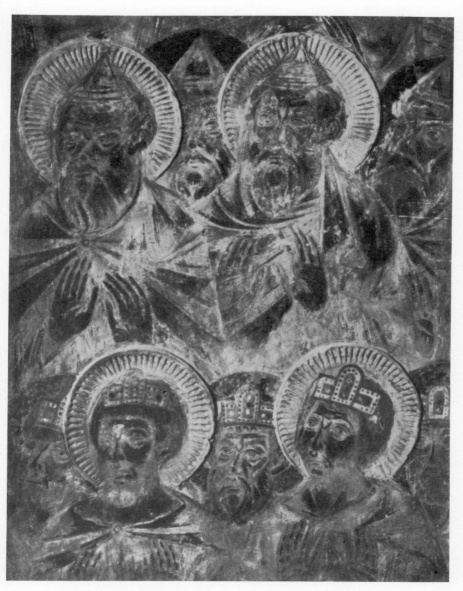

FIG. 20b. Detail from Christ and the Virgin Enthroned. Cimabue. *Photo Brogi.*

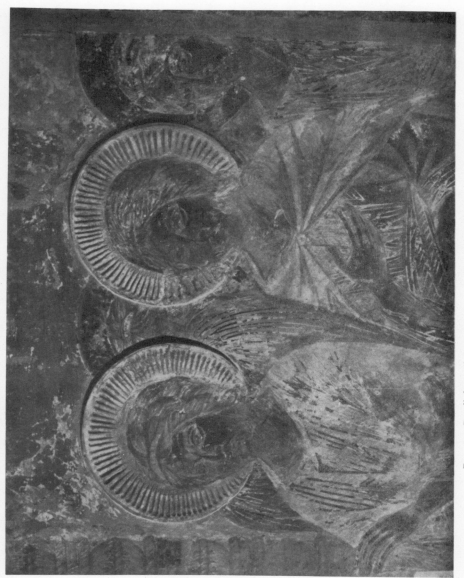

FIG. 20c. Detail from Christ and the Virgin Enthroned. Cimabue. *Photo Brogi.*

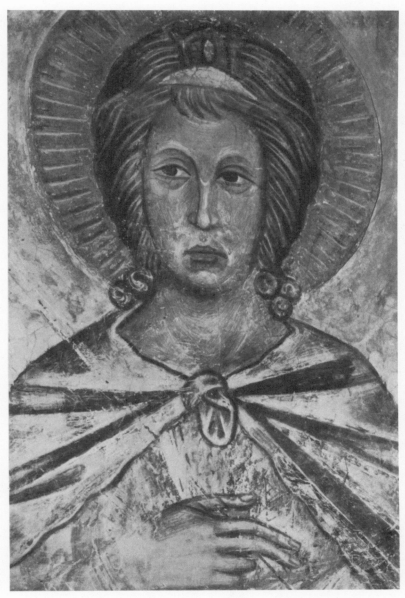

FIG. 21. Assisi: Upper Church, Left Transept. Angel. Assistant to Cimabue.

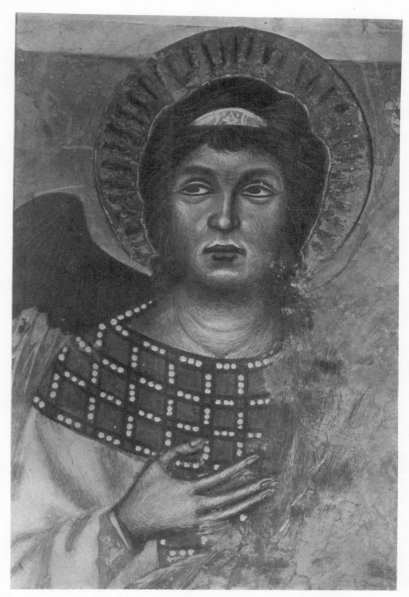

FIG. 22. Assisi: Upper Church, Left Transept. Angel. Assistant to Cimabue.

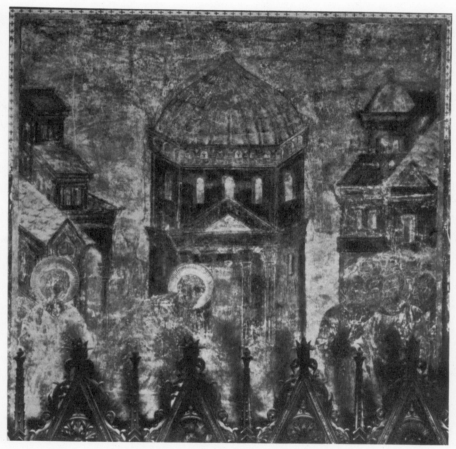

Fig. 23. Assisi: Upper Church, Right Transept. St. Peter Healing the Lame Man. Cimabue. *Photo Anderson.*

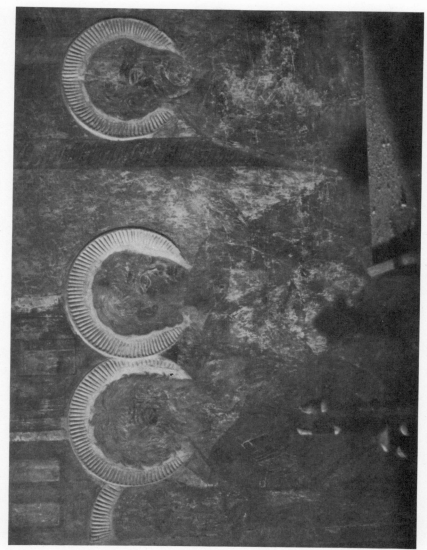

Fig. 24. Assisi: Upper Church, Right Transept. Detail from St. Peter Healing the Sick. Cimabue. *Photo Brogi.*

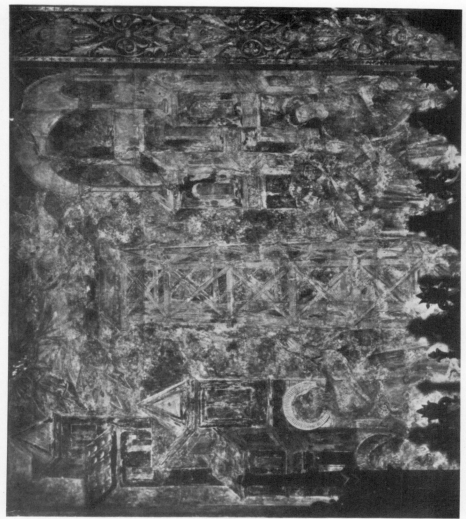

FIG. 25. Assisi: Upper Church, Right Transept. The Fall of Simon Magus. Cimabue and Assistant. *Photo Anderson.*

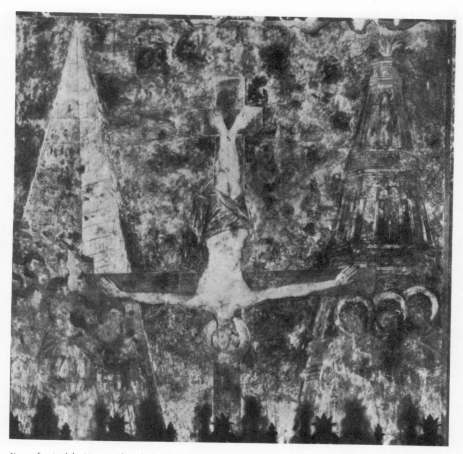

FIG. 26. Assisi: Upper Church, Right Transept. The Crucifixion of St. Peter. Assistant to Cimabue.
*Photo Anderson.*

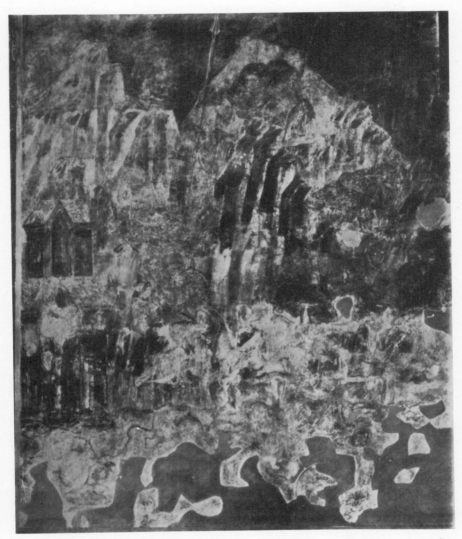

FIG. 27. Assisi: Upper Church, Right Transept. The Beheading of St. Paul. Assistant to Cimabue.
*Photo Carloforti.*

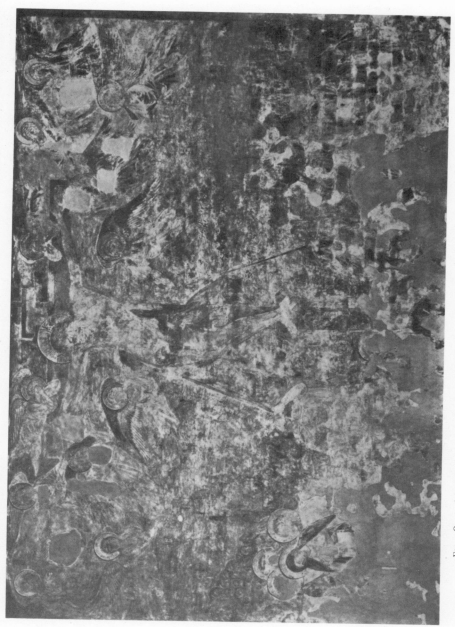

FIG. 28. Assisi: Upper Church, Right Transept. The Crucifixion. Cimabue and Assistant. *Photo Anderson.*

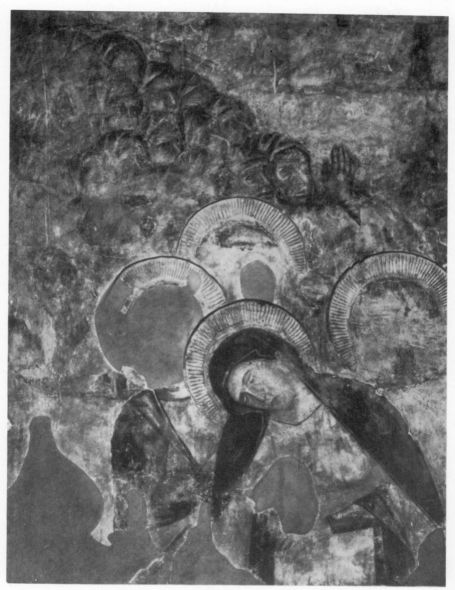

Fig. 28a. Detail from the Crucifixion. *Photo Brogi.*

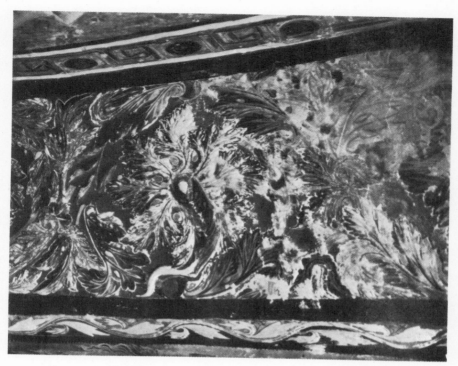

FIG. 29. Assisi: Upper Church, Right Transept. Decorative Strip. Pre-Cimabue?

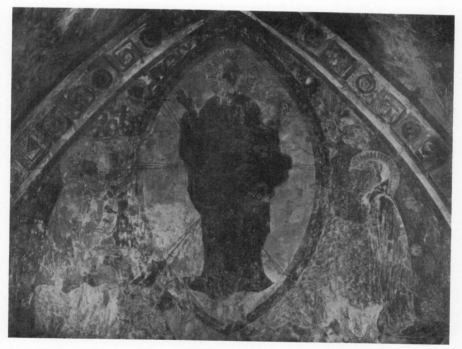

FIG. 30. Assisi: Upper Church, Right Transept. The Transfiguration. Pre-Cimabue?

FIG. 32. Assisi: Upper Church, Right Transept. A Sainted
King. Pre-Cimabue? *Photo Brogi.*

FIG. 31. Assisi: Upper Church, Right Transept. A Patriarch?
Pre-Cimabue? *Photo Brogi.*

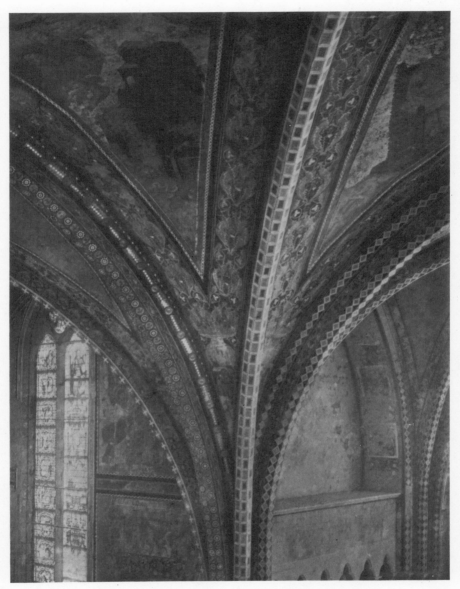

Fig. 33. Assisi: Upper Church. Choir. Ribbing and Ornament.

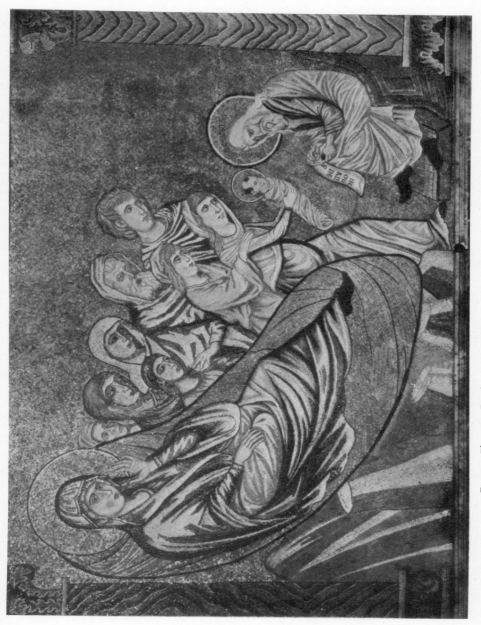

FIG. 34 Florence: Baptistry. The Infant St. John Before Zacharias. *Photo Alinari.*

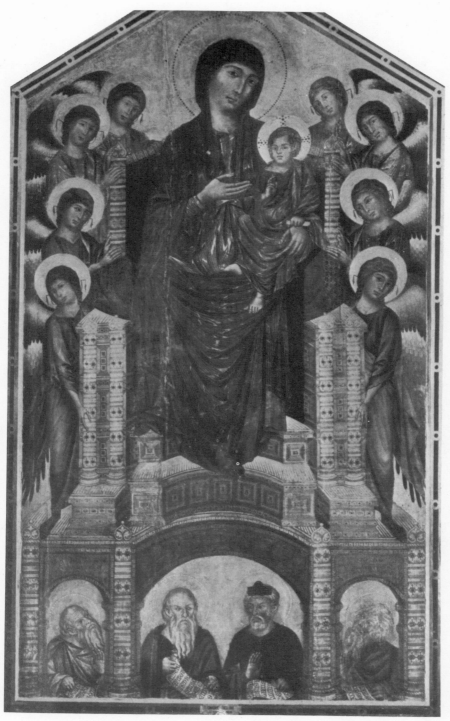

Fig. 35. Florence: Uffizi. Santa Trinità Madonna Enthroned. Cimabue. *Photo Brogi.*

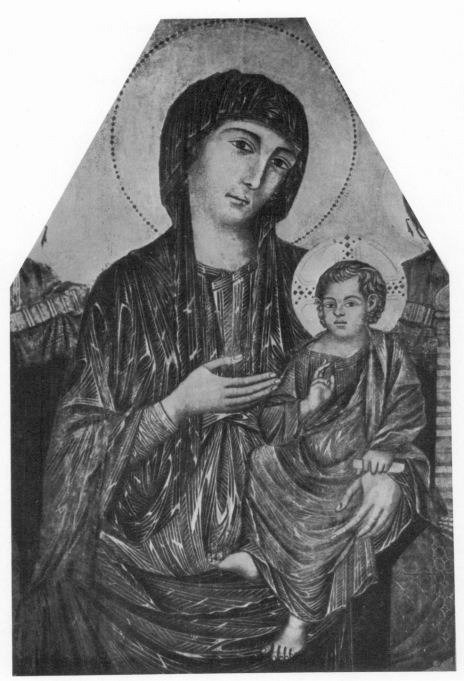

FIG. 35a. Detail from the Santa Trinità Madonna Enthroned. *Photo Alinari*.

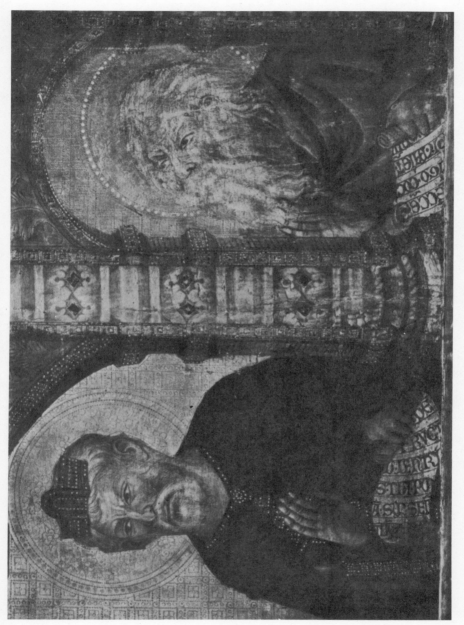

Fig. 35b. Detail from the Santa Trinità Madonna Enthroned. *Photo Brogi.*

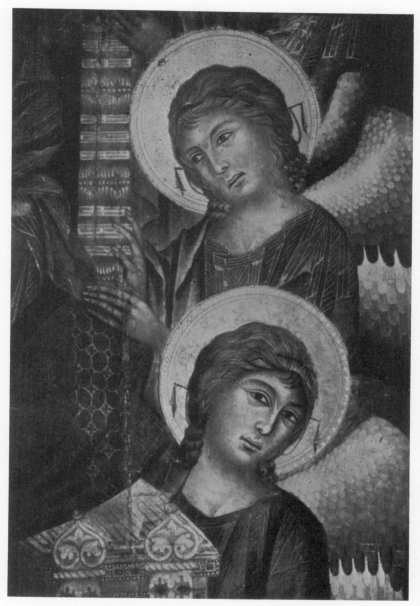

FIG. 35c. Detail from the Santa Trinità Madonna Enthroned. *Photo Brogi.*

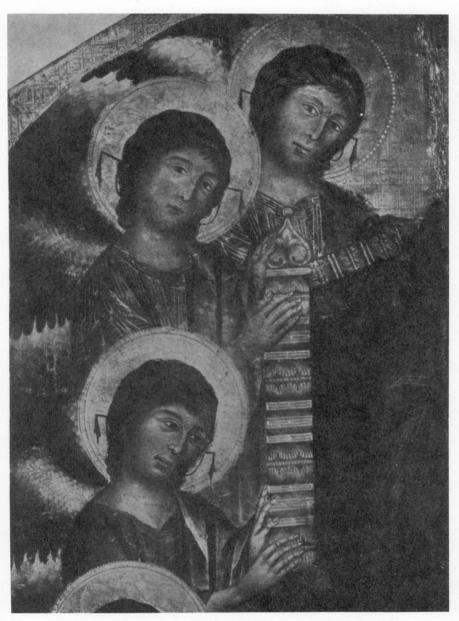

FIG. 35*d*. Detail from the Santa Trinità Madonna Enthroned. *Photo Brogi.*

FIG. 36. Orvieto: Servi Church. Madonna Enthroned. Coppo di Marcovaldo.
*Photo Alinari.*

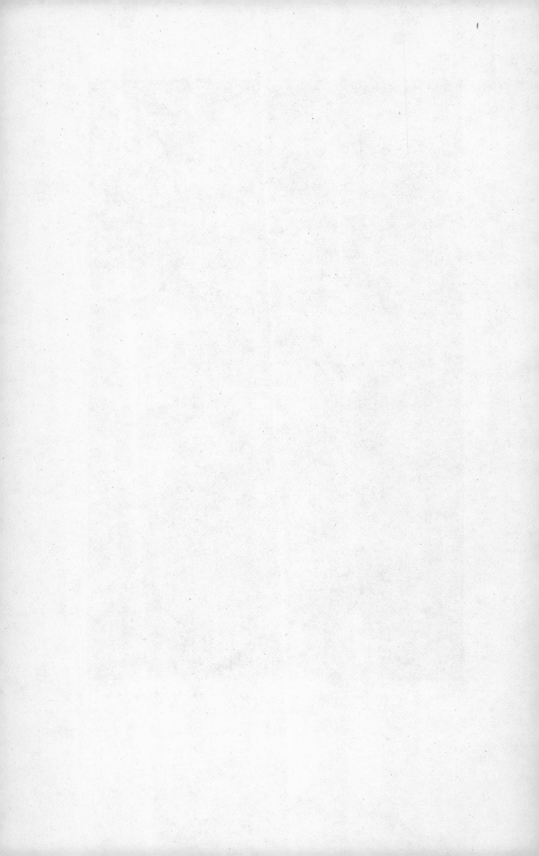

Fig. 37. Assisi: Lower Church, Right Transept. The Madonna Enthroned, and St. Francis. Cimabue.
*Photo Alinari.*

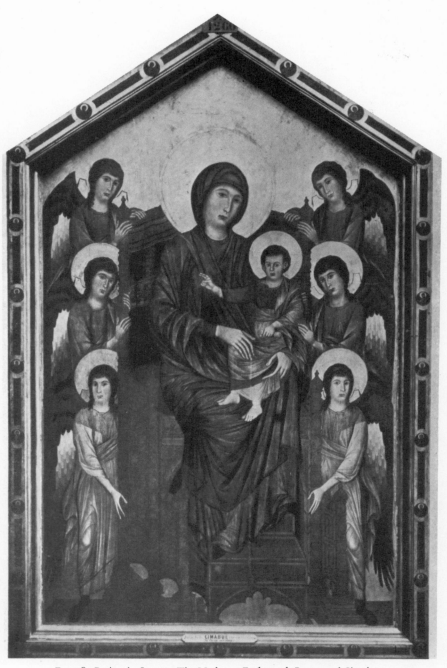

Fig. 38. Paris: the Louvre. The Madonna Enthroned. Bottega of Cimabue.

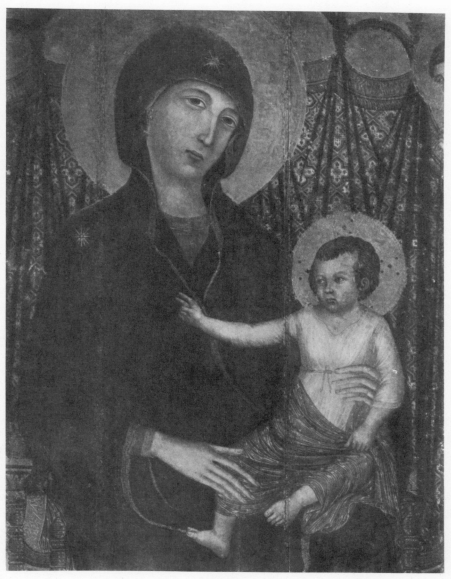

FIG. 39. Florence: Santa Maria Novella, Chapel of the Rucellai. Detail from Madonna Enthroned.
Duccio? *Photo Alinari.*

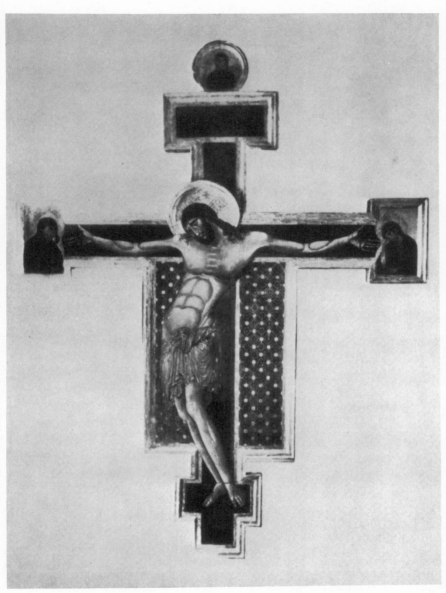

FIG. 40. Arezzo: San Domenico. Crucifix. Cimabue. *Photo Uffizi.*

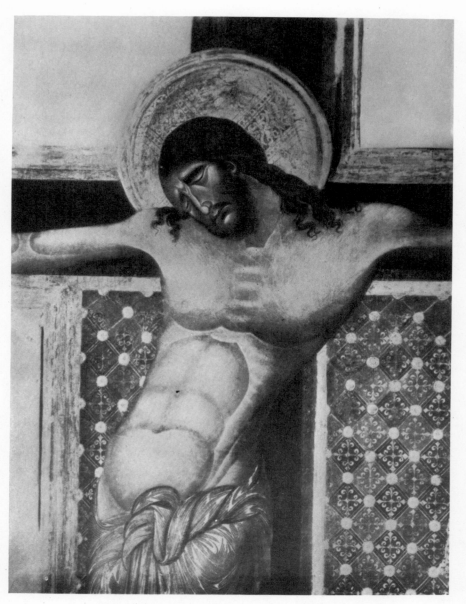

FIG. 40a. Detail from Crucifix of San Domenico in Arezzo. *Photo Uffizi.*

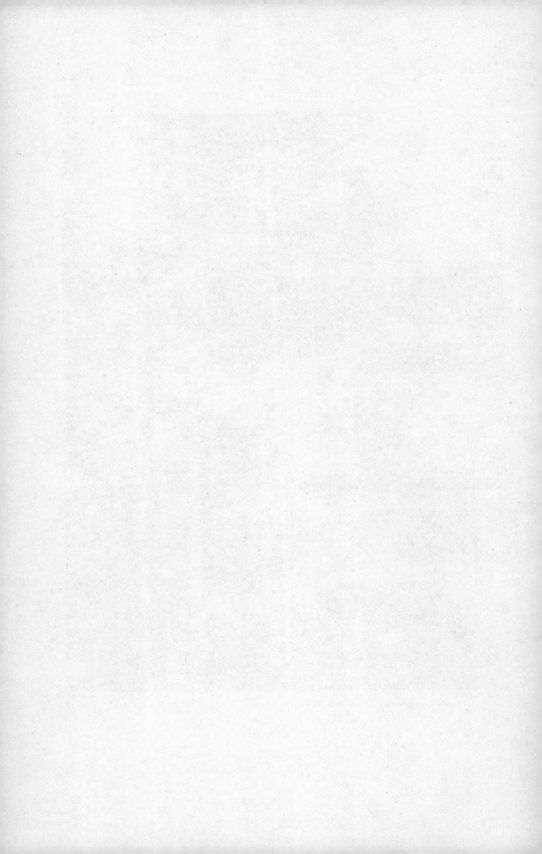

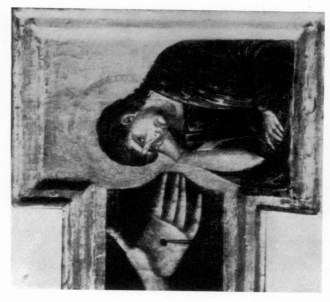

FIG. 40c. Detail from Crucifix of San Domenico in Arezzo.
*Photo Uffizi.*

FIG. 40b. Detail from Crucifix of San Domenico in Arezzo.
*Photo Uffizi.*

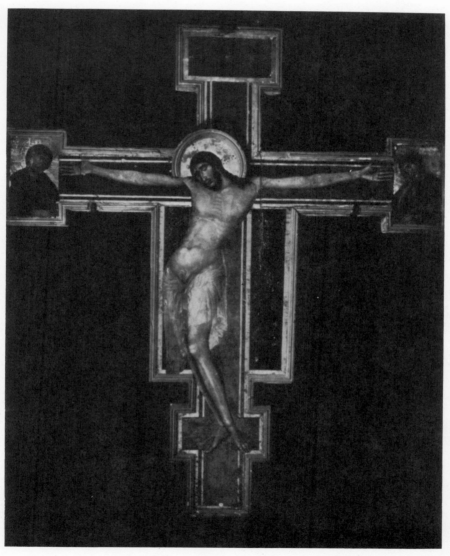

FIG. 41. Florence: Museo dell'opera di Santa Croce. Crucifix. Cimabue and Assistant.
*Photo Brogi.*

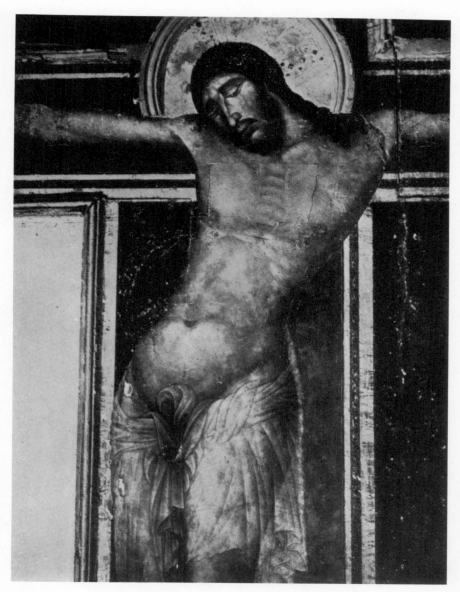

FIG. 41a. Detail from the Santa Croce Crucifix. *Photo Brogi.*

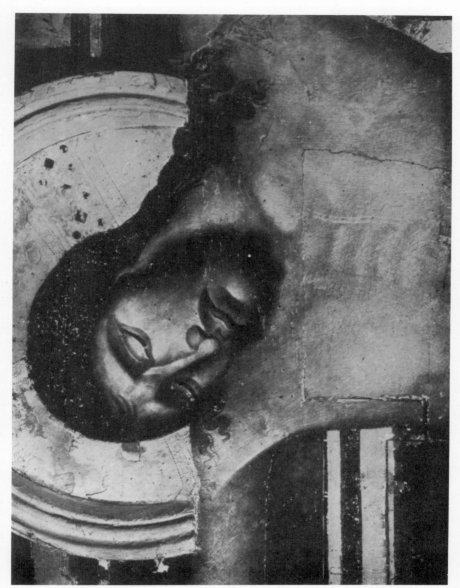

Fig. 41b. Detail from the Santa Croce Crucifix. *Photo Brogi.*